fourfield:

Computers, Art & the 4th Dimension

fourfield:

Computers, Art & the 4th Dimension

Foreword by Rudy Rucker
Introduction by Linda Dalrymple Henderson

Tony Robbin

A Bulfinch Press Book
Little, Brown and Company
Boston Toronto London

First Edition

Library of Congress Cataloging-in-Publication Data

Robbin, Tony.
 Fourfield: computers, art, and the fourth dimension/Tony Robbin;
with a foreword by Rudy Rucker and an introduction by Linda
Dalrymple Henderson. — 1st ed.
 p. cm.
 "A Bulfinch Press book."
 Includes bibliographical references and index.
 ISBN 0-8212-1909-X
 1. Computer art. 2. Fourth dimension. I. Rucker, Rudy v. B.
(Rudy von Bitter), 1946– II. Henderson, Linda Dalrymple, 1948–
III. Title.
N7433.8.R6 1992
760—dc20 91-37250

Bulfinch Press is an imprint and trademark of Little, Brown and Company (Inc.)

Published simultaneously in Canada
by Little, Brown & Company (Canada) Limited

PRINTED IN THE UNITED STATES OF AMERICA

To Rena and Max, my other two wishes

Contents

For a hundred years mathematicians have been drawing pictures of
figures in four-dimensional space. It is now recognized by art historians
that these esoteric drawings are one of the three or four main sources
for the invention of modern art. Now, with the use of computers, it
is possible for all to see the fourth dimension directly and to perceive
it as real.

Space in art has always developed parallel to space in mathematics and
science, because "space" is a cultural concept. Looking at the concept
of space in ancient Greece, in the Renaissance, and at the beginning of
the twentieth century makes this claim clear. What our culture is now
telling us about space is not that it is a field (a concept from Van Gogh's
time, still called modern), but that it is a network of wormholes.

The geometry of four spatial dimensions teaches us to distinguish
between slices and projections of geometric figures. This distinction
helps us to understand relativity as well as leading to a new strategy
of making four-dimensional works of art.

Humans have a special biology that enables us to see and make
sense of patterns. "Space" is really the functioning of the right brain.
Four-dimensional space means patterns of four-dimensional figures.
A wholly new class of patterns — quasicrystals, which are nonrepeating
patterns in three-dimensional space — behave as though they were
four-dimensional. Quasicrystals can be exploited for a marvelous new
architecture of rich ambiguity, flux, and subtle order.

5. Curvature: Lobofour and Nonclid

The most dramatic breakthroughs in contemporary geometry are in topology. Computers applied to curved and strangely connected three-dimensional spaces are causing a revolution in seeing. Such new spaces will inevitably enrich our pictorial arts.

6. Time *in* Space: Three Enigmas of Space

In spite of all these new spaces seen, the concept of space is still full of paradox: how quantum effects can occur in space, whether empty space has any substance, and how space makes time be an arrow. All these questions are now considered legitimate concerns of geometry that mathematicians and physicists are beginning to address.

7. Exebar Speaks!

Artists are applied mathematicians, and thus mathematicians can learn about mathematical creativity from them. My generation was captivated by Oriental art, which embodies spatial concepts we intuit to be relevant to our own culture and to the completion of our personalities. The emotional satisfaction of these new geometries is discussed.

Acknowledgments

Gail Rentsch, Barbara Burn, and my agent Robin Straus have put their hearts into this book, for which I will always be grateful. Above all Brian Hotchkiss, my editor at Bulfinch, fought for the book and collaborated on it as though it were his own. Although the contribution to my work of many scholars, mathematicians, and scientists is documented in the text, special thanks must be given here to Linda Henderson, for her introduction and many years of friendship, and to Rudy Rucker, for his foreword. Tom Banchoff, Roger Malina, and Larry Abbott have read the manuscript and offered suggestions and support.

Of all the people who have helped me write the computer programs that are the basis of my understanding of space, John Schnell has been the most generous; I could not have built my system without his help. Kurt Baumann of Artware+Software prepared the programs for general release with this book, and worked hard to bring them to their current form. Will Johnson of Fast Forward Technologies assisted on the Macintosh versions. I am very grateful to Nelson Ford and PSL for their wonderful offer of free distribution of the software that adds so much to the book. Michael Bondanza, Richard Brown, and the New York University Robotics Lab deserve credit for the fabrication of quasi-crystal prototypes and components. Tibor de Nagy, Jacque Holmes, and Randy Rosen have sold many of the works discussed here, and thus they are part of their creation.

No artist works without other artists. To Richard Friedberg, Fred Guyot, Al Held, Joyce Kozloff, and Hiroshi Murata, I want to say that I have admired and been influenced by your work, been braced by your example, and relished your friendship.

Foreword
by Rudy Rucker

Over the years, I've met a number of artists interested in pursuing a deeper connection with mathematics. Some artists are attracted by math's pure meta-language of platonic forms; others seek math out for the jabberwocky weirdness of its semiotic texture.

In 1984, my work on the fourth dimension brought me together with my favorite mathematizing artist, Tony Robbin. Tony and I met as guests at a conference honoring the centennial of the publication of Edwin Abbott Abbott's *Flatland: A Romance of Many Dimensions.* The conference was organized at Brown University by Thomas Banchoff, creator of a famous computer video called *The Hypercube* and author of *Beyond the Third Dimension.*

The significance of *Flatland* for the fourth dimension is that *Flatland* describes a two-dimensional denizen of a plane. His name is A Square, and he is trying to understand the idea of a third dimension that is perpendicular to all the directions that he can point to. This is entirely analogous to our quest to understand a fourth dimension that is perpendicular to all of our space directions. Four is to three as three is to two.

I don't know how many times I've analyzed some four-dimensional situation by imagining how A Square would experience a similar three-dimensional setup. What, for instance, would I see if a four-dimensional creature were to stick its hand into my room? Well, what would A Square see if I stuck my hand into his room? He would see five disconnected irregular blobs (the cross sections of my fingers), and if I were to push my hand farther, A Square would see the blobs fusing into a single large blob (my wrist). Therefore if a four-dimensional creature sticks its hand into my room, I might see five skin-covered shapes bobbing around. If they close in around me, I know I'm being grabbed!

After meeting Tony at Brown, I made a visit to his New York studio during my next trip to the big city. I was living in Lynchburg, Virginia, at the time, and would make an annual trip northward to meet with my agent and various publishers. Unfortunately for the coherence of my visit with Tony, I'd spent the early part of the day drinking beer with Barry Feldman, another artist friend, and I reached Tony's studio somewhat the worse for wear. Nevertheless, I was

very strongly affected by seeing the wall-mounted color-lit hyperspace works he was then creating. I only wish I had one at home to examine every day, and barring that, I wish my local art museum would buy one.

One of the points Tony stresses is that one's images of hyperspace can be projections rather than slices. The hand example above is phrased in terms of taking lower-dimensional cross sections of a higher-dimensional object. But what if I were to show my hand to A Square by shining a light down onto his plane and moving my hand to cast finger-shadows? He would see a dark blob with five projecting blobs. We who are used to three-dimensional space can quite easily construct a mental image of a three-dimensional object by looking at its changing shadows. Could A Square learn to do the same? Perhaps.

Numerous computer programmers have carried out the "shadow" program by writing programs that show a "shadow" of a four-dimensional object. Most programs show the hypercube. There are five other regular four-dimensional shapes, collectively known as polytopes, and some programs show these as well. One of the interesting things Tony has done in the programs available with this book is to show an object made up of a number of hypercubes. Of course a computer screen is two-dimensional, so one is really working with a double projection — as if I were to project the shadow of a cube onto a plane, and then project the plane onto a line.

Could anyone looking at light and dark patches moving on a line build up an image of a cube? It's not really as bad as it sounds. For think again of A Square. Just as our retina is a two-dimensional patch of nerve endings, A Square's retina is a little one-dimensional line of rods and cones. Due to his experience with two-dimensional space, our noble Square knows how to build up a mental image of the two-dimensional object that is producing the one-dimensional patterns on his retina. In the same way, your experience with three-dimensional space enables you to build up a three-dimensional mental image from two-dimensional patterns on your retina. Even if these patterns come directly from a two-dimensional computer screen, you can still build up an image of a three-dimensional object. The point is that although a computer screen is two-dimensional, you can perceptually experience it as a glass window looking into a space with three-dimensional objects. Indeed, a big part of the art and science of computer graphics concerns ways to make screen images really seem to be showing a three-dimensional object.

So, granted, the computer screen can show you a changing three-dimensional

object that is mathematically computed to be a correct "solid shadow" of a four-dimensional construct. By looking at such images long enough, can you form a good image of something four-dimensional?

In *Fourfield*, Tony writes movingly about his first experience with Thomas Banchoff's computer images of four-dimensional polytopes:

"For three nights, I woke frequently from dreams of the images that I had seen on Banchoff's computer: the green screen, the quivering geometric figure. It seemed as if these images were imprinted on my mind. I had seen the fourth dimension directly. Here at last was the secret I needed to fulfill my ambitions."

My first exposure to Banchoff's images affected me equally strongly. In my case, however, the dreams had a nightmarish quality. There is something irredeemably uncanny about the fourth dimension. The great horror writer H. P. Lovecraft makes use of this in some of his Cthulhu mythos stories, where door and floor slant and hinge at impossible angles. The most starkly terrifying four-dimensional nightmare I ever had was sometime around 1975. All night I dreamed of shrinking, down to the cell level, and down past that to the molecular and atomic level. As in my novel *Spacetime Donuts*, the whole universe was to be found in each atom, but with the weird effect that making the trip around the loop had turned me inside out — just as the bounding cubes of a hypercube seem to turn inside out when it rotates. When I woke up, the universe was somehow *inside* the box made by the walls of my bedroom and I was outside. All the world was inside my skin, and my body was the endless space outside my skin. To make things worse, the room blandly changed into its mirror image while I looked at it.

The brain is a fabulously complex web of messages and connections. Even though the matter of the brain is strictly three-dimensional, there is no reason the brain cannot build up an accurate model, or "dynamic shadow," of a four-dimensional construct. This is just what Tony Robbin's work accomplishes. And, actually, once you get used to it, seeing four-dimensional things isn't really so terrifying. Indeed, Tony's beautifully colored constructions make the fourth dimension into a field of pleasure and happy awe.

In *Fourfield*, Tony makes much of a particular aspect of projections, the fact that in certain arrangements, some parts of a projection will remain motionless while other parts change. This seems to be a key point in his four-dimensional thinking, and it was something I had not properly understood until reading this volume.

The point is that if you have a wire cube sitting on a piece of paper, then no matter how you move the projecting light around, the shadow of the cube's bottom face will always be in the same place. This is because the bottom face of the cube is actually embedded in the space into which one projects. The cube's shadow is a net of lozenge-shapes, with one lozenge that maintains a fixed, square form. This is also the case if, instead of moving the light, we slide the cube about on the paper. A square with fixed angles turns this way and that, surrounded by a net of lozenges whose angles shift and change. One part's shape is constant, and the other parts' shapes change.

In Tony's great wall constructs, he achieves the four-dimensional analogue of this effect: he gets a pattern of parallelopipeds in which one element stays the same, but other elements have angles that shift with the viewer's motions. It is as if we had a hypercube with one of its cubical faces motionlessly anchored in our space, but with its other faces up in four-dimensional space and being varyingly projected into our space. What we are seeing seems three-dimensionally impossible. The lights, rods, and transparent colored panels create a state of complete dimensional confusion. And, marvelously enough, the confusion is joyous rather than sinister.

One of the valuable things about *Fourfield* is that it places this kind of artistic/scientific experiment in a broader context. As Robbin puts it, not only do artists develop when they pretend to be scientists, scientists should pretend to be artists. "Abandon thy slide rule . . . and take in a few shows," exhorts Tony, arguing that art can lead the way for science.

This really struck home for me with regard to the new kind of space called *cyberspace*. Originally, "cyberspace" was a word coined by the cyberpunk science fiction writer William Gibson. Gibson's cyberspace is something like the computer network that hackers can log into, yet it is the network experientially presented as three-dimensional color graphics images by a device known as a "deck." At a higher level, Gibson's cyberspace is more than just a computer network, it's a whole independent culture and reality. Cyberspace oozes out of computers like dry ice vapor pouring from a bank of fog machines.

As Robbin would expect, the science-fictional cyberspace became a self-fulfilling prophecy. One of the hottest emerging computer technologies is something known variously as virtual reality, artificial reality, or cyberspace. This "scientific" cyberspace is a dramatic extension of the computer graphics tricks that make the user feel the computer reality is truly three-dimensional.

12

Unlike Gibson's "artistic" cyberspace users, the "scientific" cyberspace users do not need to have plugs installed in the base of their skull. A present-day cyberspace system consists of three parts: a fast graphics computer, a set of Eyephones, and a pair of Datagloves. "Eyephones" and "Dataglove" are names trademarked by VPL, Inc., a Silicon Valley company founded by the virtual-reality pioneer (and son of a science fiction writer) Jaron Lanier.

A cyberspace graphics computer maintains an accurate three-dimensional model of some scene, say a room with furniture in it. Though the computer's program and memory are just lowly one-dimensional arrays, a clever enough program is able to rapidly generate an appropriate two-dimensional image of the room's view from any vantage point. In a virtual sense, there is a three-dimensional room stored in the computer.

In order to enhance the feeling of being in that virtual room, the user wears a headset with two small television screens functioning as magic spectacles. A sensor in the headset detects the motions of the user's head, and adjusts the views in the screens accordingly. You can turn your head and see an image of the virtual wall behind you. To complete the user's immersion in cyberspace, the computer supplies images of the user's hands. Each Dataglove has optical-fiber sensors that feed the computer information about the angles of the joints of the user's fingers. The graphics computer creates hand images that match the positions and flexions of the user's hands. The gloves, by the way, are made of that most ubiquitous California fabric: Spandex.

Along with Gibson, Bruce Sterling, and a few others, I was one of the small group of writers who became known as cyberpunks in the eighties. We wrote about intelligent computers and about sex, drugs, and rock and roll. In the nineties, as fate would have it, I get the bulk of my income by working for a Silicon Valley software company known as Autodesk, Inc. What have I been working on for the last year? Nothing other than cyberspace. Autodesk's main product is a drafting program known as AutoCAD. The research division of Autodesk is working on tools to make it easier for people to write programs that function in cyberspace. An ideal end result might be a "cyberCAD" program that would allow an architect and a client to "walk around" in a virtual model of the house the architect has planned, or that would allow an engineer to pick up a virtual chisel to shape the fin of a virtual turbine fan he or she is designing.

The very first cyberspace program I wrote was a world in which I could view

a tumbling hypercube. Due to the power of the cyberspace system, I was able to model the projections as solid shapes instead of as the wire frames that past four-dimensional projection programs had used. I was surprised at what I saw. The shapes looked like caskets. I had the old inside-out nightmares again. But if I show Tony this new world, he'll find a way to make it wonderful and happy.

Reading *Fourfield* challenged me to try and analyze how I think about space, and about what the space of virtual reality should be like. In a computer simulation, you can hyperjump from here to there as fast as you want. So does distance still have a meaning? As a first approach, cyberspace programs are making images of three-dimensional reality. But is this the best way? Perhaps the size of an object should depend on how interested in it you are, instead of on how far away from you it is. Maybe a slight left and right motion of your head should scan into different regions of a four-dimensional space. Perhaps a good space organization would be that of a fractal tree in which each room has little subrooms with smaller roomlets in that — only each room feels normal-sized when you go into it.

Creating a computer program or a scientific theory is an insanely slow and frustrating process. If one line of a computer program is wrong, the program doesn't run at all. Progress is so very slow. Yet a painting with one false brushstroke is still quite OK; or, who knows, maybe the false brushstroke was even a good idea. Artists are free to think and work so much faster than scientists.

What is the best way to design cyberspace? Only an artist like Tony Robbin can show us the way.

Introduction
by Linda Dalrymple Henderson

I first met Tony Robbin in 1979 through a colleague at the University of Texas, philosopher Bob Solomon. Upon hearing me talk about early twentieth-century artistic interest in the fourth dimension, Solomon remarked that he knew a painter in New York who "talks about the fourth dimension all the time." This came as a great surprise to me, since, while my research convinced me that the fourth dimension was a central theme in early modernism, I believed that concern with a spatial fourth dimension had largely waned by the thirties. Bob Solomon put me into contact with Robbin, and, just as I was delighted to discover a contemporary artist carrying on this tradition, he was surprised and pleased to encounter prominent precursors in the quest to represent four-dimensional space.

I have since followed with great interest the evolution of Robbin's work — a creative journey that has led from his participation as a member of the Pattern Painting movement of the seventies through a remarkably fruitful period of scientific study joined with artmaking research during the later seventies and eighties. To a degree unparalleled among contemporary artists, Robbin has worked closely with prominent mathematicians, physicists, and computer experts, as described in the vignettes interspersed through the text of his book. Moving beyond the confines of the art world as such, he now lectures before audiences that include computer graphics specialists, scientists, engineers, and architects as often as specifically art-oriented listeners. Robbin's interdisciplinary approach, culminating in the present book, reflects his conviction that the artist and scientist must come together for their mutual benefit.

The intensity of Robbin's commitment to artmaking as a process of epistemological discovery finds its closest analogue in artists of the early twentieth century such as the pioneer of abstraction František Kupka and his younger cohort, Marcel Duchamp. These artists, working in pre–World War I Paris, recognized the radical redefinition of reality occurring in contemporary science and eagerly explored the ramifications of these changes for their art. Not yet aware of Einstein's theory of relativity (which would be popularized only after 1919), Kupka, Duchamp, and their cubist colleagues were stimulated by a

15

succession of scientific discoveries from the mid-1890s onward — X rays, electrons, radioactivity — which suggested that reality was transparent, dematerialized, and in flux. Just as in the seventies Robbin studied relativity physics at New York University, Kupka, for example, attended lectures on physics, physiology, and biology at the Sorbonne. Duchamp actually stopped painting for some nine months in late 1912 and took a job as a librarian at the Bibliothèque Sainte-Geneviève. There he read extensively on perspective, the new four-dimensional and non-Euclidean geometries, and, as a careful examination of his notes attests, on contemporary science and technology.[1]

The new insights into previously invisible phenomena offered by turn-of-the-century science were exhilarating for early modern artists, who questioned impressionism's preoccupation with visible light and rejected the tradition of Renaissance painting, with its dependence on visible light and shadow as the primary means to define forms and on one-point perspective to describe space. Science now established that visible light was simply one relatively small range within a much larger spectrum of electromagnetic waves or vibrations, casting into doubt the hegemony of visible light as artistic tool and suggesting the possibility of a penetrating artistic vision that could, like an X ray, reveal the inner essence of forms. Duchamp's *Nude Descending a Staircase* (see opposite page) demonstrates his artistic response to the invisible reality revealed by X rays as well as to the experiments of E.-J. Marey in motion photography, which likewise chronicled the formerly imperceptible.[2]

As an alternative to perspective, which had long been questioned as an accurate record of the process of vision, Duchamp, Kupka, and the cubists likewise found in the popular notion of a fourth dimension encouragement to explore new kinds of spatial structures that could suggest a space more complex than that perceived by vision. If the cubists evoked a higher, four-dimensional reality by incorporating multiple viewpoints and allowing forms to merge with the space around them, thus denying any clear, three-dimensional reading of the object, Duchamp soon commenced a far more serious study of four-dimensional (and non-Euclidean) geometries. Indeed, he was the only early twentieth-century artistic advocate of the fourth dimension to go beyond the popular, nonmathematical literature on the subject and actually explore four-dimensional geometry itself. Duchamp's enthusiasm for the subject is recorded in Gertrude Stein's comment in a letter of 1913 that she had recently met a young artist who talks "very urgently about the fourth dimension,"[3] a statement

16

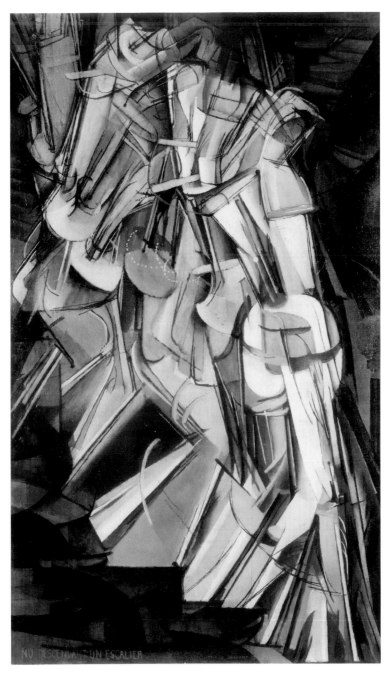

Marcel Duchamp, *Nude Descending a Staircase, No. 2* (1912).

that is reminiscent of Bob Solomon's 1979 description of Tony Robbin.

These two, Duchamp and Robbin, make an interesting pair, sharing a remarkable number of interests and attitudes. Although Duchamp's later dadalike iconoclasm has come to dominate our thinking about him, in the pre–World War I years when he was making voluminous notes for his masterpiece, *The Bride Stripped Bare by Her Bachelors, Even* (1915–1923; Philadelphia Museum of Art), he was as earnest as Robbin about the need to unify art and science. As Duchamp explained later, he "wanted to put painting once again at the service of the mind," moving it away from what he saw as a mindless preoccupation with the artist's touch and the "retinal" qualities of painting.[4] By 1913 he had assumed the persona of an engineer, making notes that drew extensively on science and technology as well as four-dimensional geometry and, ultimately, executing the work using nonpainterly materials such as lead wire and mirror silver on panels of glass. Duchamp's creaturely, biomechanical Bride in the upper half of the *Large Glass* was meant to be four-dimensional, forever out of reach of the Bachelor machines trapped in the three-dimensional, perspectival world below. Among the many scientific issues addressed in Duchamp's notes for the *Glass*, the physics of electromagnetism and, specifically, wireless telegraphy are dominant themes, with the interchange between the Bride above and the Bachelors below occurring without any physical contact.

One group of Duchamp's notes, published as *A l'infinitif* in 1966, is filled with his speculations on four-dimensional geometry, ranging from records of his study of geometrical principles to more personal extensions of these laws in the same way that his approach to science led to his "slightly distending the laws of physics and chemistry"[5] in the *Large Glass*. Like Robbin, Duchamp was interested in both projections and slices of higher-dimensional figures, and, in the end, he would explain the Bride as a two-dimensional projection or shadow of a three-dimensional Bride, who was to have been the shadow of the ultimate four-dimensional Bride. Duchamp was also keenly aware of the role time could play as a means toward understanding higher-dimensional spaces, as the following typical note, based on the writings of Jules-Henri Poincaré, suggests:

> Construct all the 3-dim'l states of the 4-dim'l figure the same
> way one determines all the planes or sides of a 3-dim'l figure
> — in other words: A 4-dim'l figure is perceived [?] through an
> ∞ of 3-dim'l sides which are the sections of this 4-dim'l figure. —
> In other words: one can *move* around the 4-dim'l figure according
> to the 4 directions of the continuum. . . . The set of these 3-dim'l

perceptions of the 4-dim'l figure would be the foundation for the reconstruction of the 4-dim'l figure.[6]

Yet, as much as Duchamp speculated in his notes, the only visual models available were geometers' conceptualizations of projections of four-dimensional figures, or partial figures, such as those of Stringham and Jouffret (figures 1.2, 1.3), and he never attempted in the *Large Glass* to present the *Bride* in complex geometrical terms.

Duchamp would have marveled at the computer-graphics images of the four-dimensional hypercube created and manipulated by mathematicians such as Tom Banchoff (figure 1.1) and by Robbin himself in the programs he has written and made available with this book. Rotation in four dimensions, which, by definition, occurs around a plane, was a particular fascination for Duchamp, and he tried in numerous notes to imagine a viewer's relationship to the familiar axes of three-dimensional space during a four-dimensional rotation. By means of computer graphics and real-time capabilities on the computer, however, Robbin and others have been able to observe repeatedly the remarkable changes that occur in a rotating hypercube. It is this experience of seeing a hypercube appear to turn itself inside out, for example, that makes it clear that we are in the presence of a new kind of space. With such images at his fingertips, Robbin has a powerful language with which to signify the fourth dimension in his works, moving far beyond the intuitive attempts of early twentieth-century seekers of the fourth dimension. "Only after seeing four-dimensional space can we hope to make four-dimensional art," Robbin declares in chapter 1.

Robbin's twenty-seven-foot work *Fourfield* demonstrates the effectiveness of the suggestion of four-dimensional rotation as a visual clue for the viewer of a painting. Over the painted planar shapes of its background, *Fourfield* presents the linear outlines of pairs of projections of component cubes of the four-dimensional hypercube, depicted both by painted lines and by wire rods extending from the surface of the canvas (figures 1.5, 1.6, 1.7; color plate 16*). The shift of the pair of projected cubes from its wire position to its painted position reflects the mutation of this segment of the hypercube as it goes through four-dimensional rotation. The experience of walking the length of *Fourfield* is a dynamic and totally new one. Unlike the works of cubism, in which multiple viewpoints ultimately fuse into unified images, *Fourfield* presents a succession of shifting views by means of pairs, which then change further as each wire model alters its shape as a result of the observer's changing vantage point.

*Color plates appear on pages 129–159. 19

If the geometrical qualities of *Fourfield* represent a realization of the kinds of spatial effects Duchamp explored in his notes, there is an important difference between these two advocates of art-as-science. Duchamp rejected painterly touch and sensuous color in his effort to create a purely intellectual, conceptually oriented art. In contrast, Robbin has never suppressed his sensibilities as a painter nourished by the great artists of color and pattern throughout history, from Islamic and Japanese artists to modern masters such as Matisse. His sensitivity to color makes these works a feast for the eye and an intellectual challenge to our conventional modes of perception. Thus, in *Fourfield* the richly colored background pattern of interlocking hexagons, squares, and rhomboids can be appreciated both as pure color and pattern on a surface and as a means to augment the spatial complexity of the painting, when these same shapes begin to join together to create Necker-reversing three-dimensional forms that further deny a single reading of any section of the work (figure 1.6).

In most of Robbin's paintings, including *Fourfield*, textural areas of color are sprayed onto the canvas in layers of irregular dots that produce the kind of optical mix associated with the divisionist, or "pointillist," painter Georges Seurat. Greatly admired by Duchamp for his scientific approach to painting, Seurat was seeking to render light more accurately than had the impressionists. Robbin's works can also be seen in this tradition of painting visible light, and his "light pieces" of the later 1980s (figure 3.8) fulfill the dreams of earlier artists to paint with light. Here paint and canvas are left behind in favor of sculptural constructions of industrially fabricated rods and colored Plexiglas, which are lit by Fresnel lamps. Illuminated from left and right with red and blue light, the rods produce remarkable stereoscopic effects when the piece is viewed through 3D glasses. (Duchamp himself was exploring similar stereoscopic, or anaglyphic, effects toward the end of his career.) Yet, while the materials are industrial — the kind favored by Duchamp — the result is one of breathtaking beauty and sensuality. Filled with uncanny spatial effects for the viewer who moves before them (with or without the glasses), these works, like *Fourfield* and Robbin's other paintings, are a blend of intellectual stimulation and retinal delight, of the invisible and the visible, of Duchamp and Monet.

If the fourth dimension of space had been a major concern for a great many early twentieth-century artists, interest in a spatial fourth dimension waned dramatically in the wake of the popularization of Einstein's theory of relativity, during the twenties. As interpreted in this period, general relativity, with its

four-dimensional space-time continuum, seemed to redefine the fourth dimension as time. In response to this new, seemingly simpler focus on time, a number of artists in the twenties worked to introduce the element of time itself into their art and theory, in order to evoke the fourth dimension.[7] In contrast to these artists, however, Robbin returns to a focus on the four-dimensional geometry basic to Herman Minkowski's original formulation of the space-time continuum in 1908, as discussed in chapter 3. In doing so, he carries forward the rich formal experimentation of early modernist artists who pursued a spatial fourth dimension — as opposed to the post-1920 focus on time, which produced far less interesting artistic results.

As his book demonstrates, Robbin believes firmly in the reality of four-dimensional space and the need for humans to develop their powers of spatial conceptualization to the new levels suggested by four-dimensional and non-Euclidean geometries as well as by the field of quasicrystal structures, in which he is currently doing pioneering work. For Duchamp, four-dimensional and non-Euclidean geometries had been mathematical issues divorced from the artist's simultaneous explorations in science. For Robbin, by contrast, four-dimensional space and relativity physics are inextricably linked, and the study of four-dimensional geometry and the curved spaces of non-Euclidean geometry (standardly used to describe the curvature of space-time) is not only research in mathematics but also in physics.

Despite the extent of Duchamp's study of science, he always emphasized that his was a "Playful Physics," and his goal, in the end, was the reform of artmaking rather than any contribution to science or mathematics.[8] Robbin, on the other hand, believes that artists, with their highly developed capabilities of visualization, can indeed contribute to the development of science and of culture as a whole. In this view he is closer to certain other early twentieth-century advocates of the fourth dimension than to Duchamp. For example, Mikhail Matyushin, an artist-colleague of the abstract painter and seeker of the fourth dimension Kazimir Malevich, expressed a similar attitude in his proclamation of 1913, "Artists have always been knights, poets, prophets of space in all eras."[9] In a late-twentieth-century recasting of that sentiment, Robbin declares to his readers in chapter 2, "When the fourth dimension becomes part of our intuition, our understanding will soar." This sense of excitement and discovery pulsates through Robbin's book, and its readers will be hard-pressed to ignore the challenge his text presents to our preconceptions about the nature of the world around us and our perception of it.

Prologue

I have a theory that new art styles are made when artists despair of ever becoming genuine artists and decide to give it all up for science, except that, having no training in science, they must continue their project — now thought of as a science project — using the artist's tools. I imagine Claude Monet recognizing his failure to paint the incidents of quotidian Parisian life with enough force and charm to blow away the art world's addiction to the set pieces of naturalism and romanticism, and turning instead to the scientific study of light on haystacks and facades at different times of day and in different atmospheric conditions. I can even hear him say *scientifique* in the way that only the French can — imbuing it with a haughty and slightly crackpot tone. Of course, Monet had the example of the younger and tragic Georges Seurat, an eccentric artist who could paint all night by gaslight because he had coloration worked out to number painting.

I can also imagine Henri Matisse despairing of ever painting light like Vermeer, and giving up art — which he recognized as a mere clinging to a craft that was beyond him anyway — and instead searching for the meaning of blue. Maybe it was not exactly psychology or environmental planning, but it certainly was not art either. That red is a meaningful experience — whoever heard of such a thing? And how, exactly, does such a statement continue the traditions of Corot and Courbet?

In fact, I can think of artists who are also philologists, geologists, psychologists, neurologists, and theologists. And if it were otherwise — if we mocked artists

and browbeat them to the extent that art was their only specialty — then artists and art would be doomed to irrelevance. Art is *supposed* to partake of the cultural and intellectual life of the period. Artists who have been around awhile and still think of themselves as artists, even in secret, are probably faking it, because they do not have any ideas and are identifying with a craft that someone else invented for some other purpose entirely. Yet in the midtown gallery buildings of New York, in elevator after elevator, I hear the art world praise the "art" and the "hand" of some painter, while ridiculing artists mercilessly for having silly ideas about how their work is integrated into the culture as a whole, and sillier still, how it might relate to new ideas in science and mathematics.

This book recounts a science project in art begun twenty years ago. It begins with an equation of inner sensibility with the structure of space "out there." It searches for a new definition of the space of objective reality, for in that world described by physics, as well as in the subjective world described by art, many events are too complicated to fit into a framework of three spatial dimensions. Physics and mathematics describe spaces far richer than any artist has yet imagined, spaces needed for the definition of inner experience, and for the completion of our aesthetic sensibility. This science project has settled on the study of four-dimensional geometry — a geometry of four spatial dimensions (time is not one of them) — on non-Euclidean geometry, and on quasicrystal geometry, and it has led me to the study of computer science, which has changed my work forever in ways that I could never have predicted.

1.

Einstein's Cave

My first experience of computer-generated four-dimensional geometry was through Thomas Banchoff, in 1979, while he was chair of the mathematics department at Brown University. I visited Banchoff and his computer science collaborator Charles Strauss in the summer of 1979, and was permitted time on the special parallel processor computer they had built. It was one of the most profoundly inspiring experiences of my life.

After years of hoping to visualize the four-dimensional cube, there it was. By moving a joystick, I could turn the hypercube in my hand. The computer recalculated the position of the object thirty times a second, so the joystick was

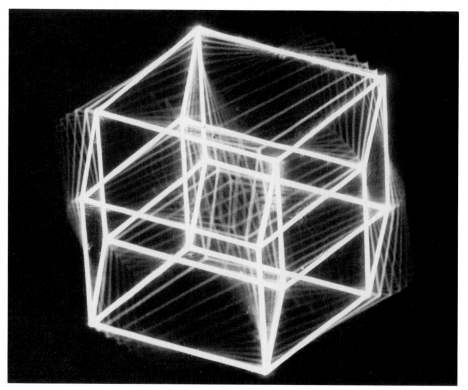

Fig. 1.1. The quivering hypercube I saw on Tom Banchoff's computer.

exquisitely sensitive to the touch and the illusion of actually handling this beloved and mysterious object was very strong indeed. It was as though I had plunged my hands through the computer screen to touch it. There was no question of this figure's being a complicated three-dimensional object; it behaved in ways I had never seen, flipping inside out as it turned around, dissolving and reconstituting itself before my eyes. Like quicksilver in the palm of my hand, its movements were endlessly fascinating.

In a trance, I drove home the five hours from Providence to upstate New York where I was spending the summer. For three nights, I woke frequently from dreams of the images that I had seen on Banchoff's computer: the green screen, the quivering geometric figure. It seemed as if these images were imprinted on my mind. I had seen the fourth dimension directly. Here at last was the secret I needed to fulfill my ambitions (figure 1.1).

Time is not the fourth dimension. The fourth dimension is spatial, represented by a line perpendicular to each of three other perpendicular lines. This fourth perpendicular line leads out of the space defined by the other three and never intersects them. The space-time of relativity physics (where time *is* the fourth dimension, or more precisely, one of the four dimensions) is an *application* of four-dimensional geometry. We can understand what this distinction between geometry and application means by considering a map of the United States. The east-west axis runs horizontally across the page, along what by convention is the x-axis, and the north-south axis runs vertically along what is generally called the y-axis. When giving map coordinates, we usually mention the x-axis first and the y-axis second. But we do not say that north is the second dimension. We know that it is the second dimension mentioned when looking at this kind of map, but there are many situations when the second dimension is attributed to something other than north; the second dimension existed before maps of this kind were invented, and there would be a second geometric dimension if maps like this had never been invented. In other words, we do not confuse the application with the underlying geometry.

Even though space-time physics may be the most common application of four-dimensional geometry to date, the fourth dimension exists as part of a geometric entity represented by four mutually perpendicular lines independent of that application. In fact, the fourth dimension of space was known for generations before Einstein set forth the tenets of space-time physics in 1905.

Fig. 1.2. William Stringham drawing of 1880, probably the first published picture of a hypercube.

August Möbius, the German mathematician and astronomer, seems to have been first to speculate about a fourth spatial dimension. In 1827, noticing that a silhouette of a right hand can be turned into a silhouette of a left hand by passing the figure through a third dimension (one higher than the figure itself), Möbius stated that a space of four dimensions would be needed to turn right-handed three-dimensional crystals into left-handed crystals. In the 1850s two papers by the Swiss mathematician Ludwig Schläfli determined all the regular four-dimensional figures, including the star-type figures, computed their numerical and metrical properties, obtained both the four-dimensional pattern of hypercubes and the fifth-dimensional cube, and invented an elegant means of describing these figures. His work remained little known, however, and credit for many of these discoveries was erroneously given to the American mathematician William Stringham. Stringham's 1880 paper in the *American Journal of Mathematics* was less complete than Schläfli's work, but it did include, for the first time, illustrations of many four-dimensional figures (figure 1.2). These visualizations propelled the study of higher-dimensional figures as nothing had done before, captivating the imagination of mathematicians and nonmathematicians alike. Also about this time, the mathematician and philosopher Charles H. Hinton became convinced that people could be trained to see the fourth dimension of space and that an intellectual and spiritual liberation would follow such experience. Hinton's technique was to study the changing appearance of color-coded hypercubes — the four-dimensional analogue of the cube — as they passed through (were sliced by) the three-dimensional space of our normal experience.

In 1884, the English clergyman and educator Edwin Abbott Abbott published *Flatland: A Romance of Many Dimensions.* Based on a simplified version of Hinton's technique, it portrays two-dimensional creatures who are visited by a sphere from the land of three dimensions. Flatlanders attempt to comprehend the third dimension from the succession of two-dimensional slices of the sphere that appear in their Flatland. Abbott's parable is of such charm and coherence that even today it initiates people into higher-dimensional speculations.

At the beginning of the twentieth century, Jules-Henri Poincaré, even then France's most esteemed mathematician and thinker, repeatedly discussed the possibility of perceiving the fourth dimension, giving credibility to earlier speculations. In his 1902 *Science and Hypothesis* he speculated that geometry does not exist a priori in the mind, nor is it derived from the experience of the

senses. "None of our sensations, if isolated, could have brought us to the concept of space; we are brought to it solely by studying the laws by which those sensations succeed one another. . . . Well, in the same way that we can draw the perspective of a three-dimensional figure on a plane, so we can draw that of a four-dimensional figure on a canvass of three (or two) dimensions. . . . [and by studying the 'group' of these perspectives] we may say that we can represent to ourselves the fourth dimension."[1]

At the same time Poincaré was writing — the period when modern art was being invented — this idea of a fourth dimension of space was widely known by artists. Research by art historian Linda Henderson proves conclusively, with page after page of documentary evidence, that the desire to create four-dimensional art was the motivation and philosophical support for the daring leaps of abstract art and modernism in general.

Henderson's work shows that the fourth dimension was all the rage in Paris by the second decade of the twentieth century. She has discovered an issue of the literary and art magazine *Comoedia* from 1912, the first page of which is divided evenly between a review of "le Salon des Indépendants" and Gaston de Pawlowski's *Voyage au pays de la quatrième dimension*. Moreover, in 1909, when *Scientific American* sponsored an essay contest for "the best popular explanation of the Fourth Dimension," they received 245 entries from all over the world.

The artists who invented modern art did not depend on watered-down popularizations of four-dimensional geometry, however. Henderson tells us about Maurice Princet, a mathematician working as an actuary for an insurance company, who taught the new four-dimensional geometry to his artist friends — Jean Metzinger, Albert Gleizes, Guillaume Apollinaire, Robert Delaunay, Marcel Duchamp, Juan Gris, Jacques Villon, and others, including, probably, Pablo Picasso. Further, in 1903 E. Jouffret published in France an elementary text of four-dimensional geometry that included illustrations (figure 1.3). These *"perspective cavalière"* illustrations look much like early cubist works such as Duchamp's *Nude Descending a Staircase* (see page 17). In fact, Duchamp quotes Jouffret in his notes.

After investigating the development of every major modern art movement in Europe, Russia, and America, Henderson concludes:

Fig. 1.3. From E. Jouffret's 1903 text on four-dimensional geometry.
Maurice Princet could have used this text to teach four-dimensional geometry to his artist friends.

29

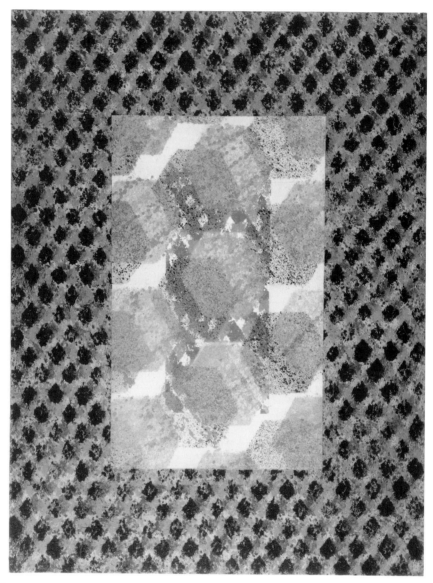

Plate 1. Untitled, 1970, acrylic on canvas, 70″ × 56″,
 collection of the artist.

During the first three decades of the twentieth century, the fourth dimension was a concern common to artists in nearly every major modern movement: Analytical and synthetic cubists (as well as Duchamp, Picabia, and Kupka), Italian Futurists, Russian Futurists, Suprematists, and Constructivists, American modernists in the Stieglitz and Arensberg circles, Dadaists, and members of De Stijl. While the rise of Fauvism and German Expressionism preceded the first artistic application of higher dimensions by the Cubists, Matisse himself later demonstrated a passing interest in the subject. And, even though the German Bauhaus was not an active center of interest in the fourth dimension, it, too, was touched by the idea through the propagandizing of Van Doesburg, Kandinsky's own awareness of the idea, and the growing interest in Germany in the space-time world of Einstein.[2]

Poincaré, as we have seen, thought it was theoretically possible to see the fourth dimension, but only by somebody "who will devote his life to it."[3] This pessimistic appraisal was reinforced in 1947 by the great geometer H.S.M. Coxeter, who wrote, "Only one or two people have ever attained the ability to visualize hyper-objects as simply and naturally as we ordinary mortals visualize solids."[4] But only a quarter of a century later the psychologist of perception Heinz Von Foerster, in reporting on perception experiments done at the University of Illinois at Champaign/Urbana in 1971 and 1972, stated unequivocally that any subject can learn to see four-dimensionally to the extent that they "show no surprise about the results of legal four-dimensional maneuvers, can spot inconsistencies in figures . . . can perform tasks in four-space, can anticipate the results of rotations in four-space . . . can manipulate one object behind another or into another in four-space, as in a 'hyper-Soma cube,' etc."[5]

The twenty-five-year span between Coxeter's pessimism and Von Foerster's bounding optimism about the human capability for visualizing four dimensions was the period during which computers were invented; Von Foerster's subjects were training on a real-time interactive computer, and carrying out precisely the study program Poincaré imagined. Unfortunately, because of a lack of funding Von Foerster could not gather a large enough sample to publish final results. He has, however, informally stated that over and over again his subjects could satisfy his elaborate protocol, and could see the fourth dimension according to his strict definitions.*

*On the disk that comes with this book is my program Hyper, which re-creates Von Foerster's training system.

ENGLEBERT SCHUCKING was the first person to tell me point-blank that he had seen the fourth dimension. When he said this, in 1975, he had graying hair down to his shoulders and was wearing a denim jacket, yet he was — and still is — an esteemed professor of relativity physics at New York University. Because of Schucking's position and reputation, as well as his tremendous personal dignity, I took him at his word, and began my long campaign to visualize the fourth dimension largely on his say-so. Apparently he also had such a discussion with the artist Enrique El Castro Cid on the subject of non-Euclidean geometry, which sent *him* on a similar quest: Castro Cid's paintings are based on non-Euclidean computer programs that he has written in Fortran. Even though I spoke to Schucking only once, albeit for several captivating hours, he is a kind of Merlin figure in my mythology. Geologically confident in his knowledge, calm in his personal bearing, he is the atavistic authority, generating his own authenticity; I can not imagine Schucking lobbying for anything. The idea of the successful academic as a kind of corporate manager, frantically juggling government grants, commercial research contracts, and the like, must be anathema to him. He is a professor of the old school.

So what does it look like? I asked him, of the fourth dimension. He said he had never bothered to stop and look at it, but recalled that the experience was marked by a stillness and beauty.

It *is* a human capability to be as comfortable seeing four spatial dimensions as seeing three. For a hundred years sensible people have tried to learn to do this. Just in the last few years have computers been able to aid in this effort. And computers, by presenting us for the first time with the actual moving images projected in our three-dimensional space, are miraculously effective learning tools. Only after seeing four-dimensional space can we hope to make four-dimensional art. Such four-dimensional works of art, if taken to heart, can change the way we see.

A two-dimensional object can rotate about a point; a three-dimensional object can rotate about a line; a four-dimensional object can rotate about a plane. It is this extra dimension of freedom of movement that distinguishes a four-dimensional object from a merely intricate three-dimensional object and reveals its true properties. Consequently, it is planar rotation that should be the focus of our attention when considering four-dimensional figures. To be sure, to the

person accustomed only to observation in three dimensions the properties of planar rotation are mysterious, even paradoxical (shapes appear and disappear, turn inside out, flex and reverse); but these paradoxes become the very means by which we see the fourth dimension.

Since planar rotation is the single most important property of four-dimensional figures, and is, in fact, the only way we can distinguish four-dimensional figures from merely intricate three-dimensional figures, works of art that propose to be four-dimensional must embody planar rotation. Anything else is like trying to live in an architect's rendering: titles notwithstanding, the work will not provide the opportunities advertised; you can not sleep in the drawing marked "bedroom" or eat out of that little box labeled "refrigerator."

I have discovered that by using a combination of two- and three-dimensional objects, taken together as a single entity, the visual information of planar rotation can be presented and the fourth dimension brought out of the computer. The strategy is to depict hypercubes, individual cells of which are made with painted lines on canvas and others of which are sculpted in welded steel rod of the same thickness and color as the painted lines. The three-dimensional cells parallax (have a changing aspect as you walk around them). But the two-dimensional cells (which are perceived as three-dimensional elements) do not parallax; they remain fixed and only seem to move relative to the sculpted cells. The viewer sees a figure that partially rotates and partially does not, a property of planar rotation familiar to us from computer-generated rotations.

Rather than spend a year or two making smaller works, I wanted to celebrate my discovery with a gigantic work. After three months of drawing my enthusiasm could not be contained and erupted with an 8½-by-27-foot work, which I called *Fourfield* (figures 1.5, 1.6, 1.7; color plate 16*).

All the paradoxes of planar rotation are vividly present in *Fourfield*. Cells are hidden behind planes, and a slight movement on the part of the viewer spins a space out of a place where there had been only flatness. Parts of geometric figures taken to be rigid structures move relative to each other; they flex even though the artwork has no moving parts. Sometimes the painted cell is more spatial than the sculpted cell; it often appears to be the moving one, providing that special relative motion of planar rotation where some cells of a hypercube move clockwise and others counterclockwise. Finally, these seemingly rigid geometric objects pass through each other with the paradoxical ease of shadows of a skeletal cube swimming through each other.

*Color plates appear on pages 129–159.

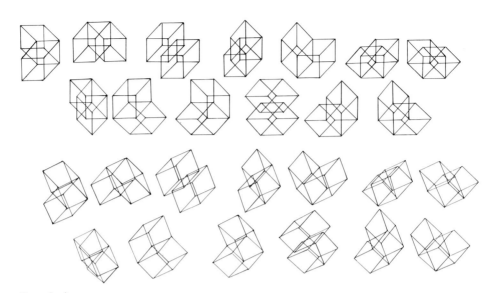

Fig. 1.4. Two cell groupings of the hypercube's eight cells and their planar rotations.

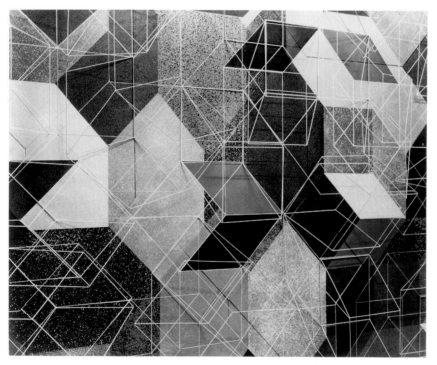

Fig. 1.5. *Fourfield* (detail). The welded steel rods and the painted lines work together to provide the visual information needed to show planar rotation.

To find a car in the parking lot only a space of two dimensions is needed, and to conceptualize the parking lot as a space of three dimensions is a needless complication. To pick apples from a tree with a two-dimensional map, however, is hopeless: the instruction to pick the apple on the outside left means nothing unless the height of the branch to be picked is specified. And rather than a messy pile of two-dimensional maps, one for each height of branch, it is more direct and simple to have a three-dimensional model of the tree, even if it is merely molded out of air by the person instructing the picker. People seem to need to deal in "reality" rather than "models." The parking lot is "really" two-dimensional, though of course nothing physical can have only two dimensions. Likewise no one leans a ladder against an apple tree without knowing that it is "really" three-dimensional. Physics teaches that many objects in the universe are best described by a geometric model that is four-dimensional. We can consider that model real; indeed, it must become real for us if we are to work with it efficiently.

Consider the shadows on the wall of Plato's cave. These shadows result from dancers positioned behind the viewers' backs, dancing in front of a fire. The spectators are forbidden to turn and face the dancers. But with a sophisticated mathematical system that could keep track of the changing size of the fire and its distance from the wall, the viewers' changing distance from the wall, the curvature of the wall itself, the changing size of the dancers, and their changing proximity to the wall and to the fire — if all this could be kept track of, then the phantasmagorical images on the wall could be seen to result from the integral beings of dancers. The viewers have no trouble accepting the dancers

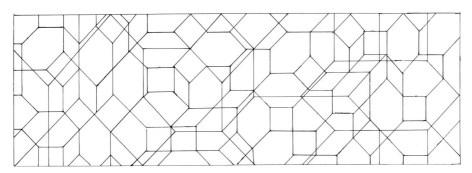

Fig. 1.6. Grid for *Fourfield*. Two-dimensional slices through hypercubes,
at two scales, make up a nonrepeating pattern.

35

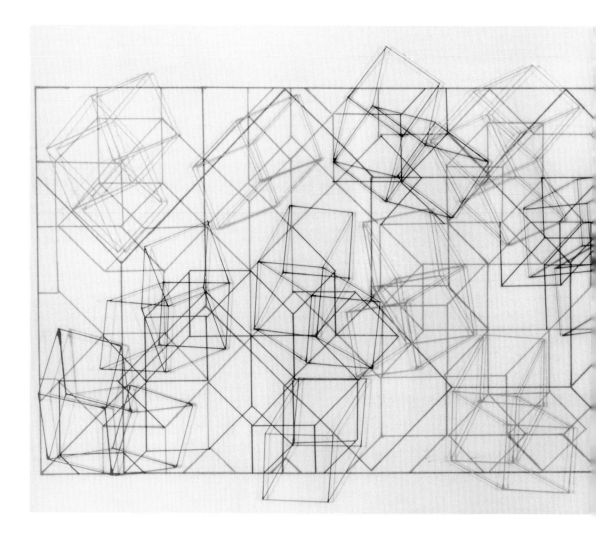

Fig. 1.7.

Tony Robbin, *Fourfield* (print). The steel rods are represented in the

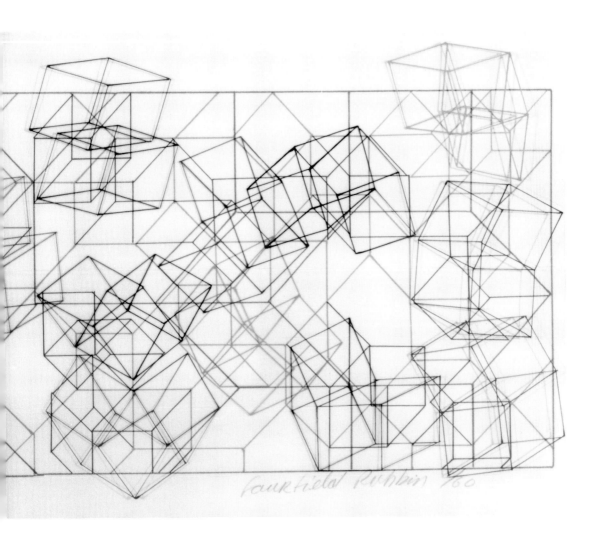

print by a transparent overlay, matted out from the printed page.

as real rather than as mere bookkeeping devices. Why? They see only their shadows and must learn to see their full three-dimensional forms from the moving shadows alone. Yet they nevertheless accept the dancers as real because the dancers are the integral (the symmetrical) origin of the otherwise disorganized shadows, and because there is nothing sacrosanct about a geometry of just two dimensions.

We can speculate with confidence about the experience of the dwellers in Plato's cave because, outside the cave, we make a similar leap of faith. The light from objects that reaches our eyes comes in a rapid succession of two-dimensional sheets, but we "see" the three-dimensional objects, not their changing two-dimensional colored shapes. It is true that our visual experiences are backed up by tactile ones, and we can later feel the solidity of what we see. But we must recognize that the human body has no mechanism for directly seeing the "reality" of the third dimension of objects.

Now, in Einstein's cave, the shadows we observe are three-dimensional; they have mass, exist in time, and obey physical laws. But these shadows, too, are phantasmagorical. Their shapes, masses, and internal clocks are different for just about every viewer, owing to relativistic effects. For some viewers, the physical attributes of the shadows are *vastly* different, and sprouts grow into huge oak trees that wither from old age in the time it takes to drink a cup of coffee. To be faithful to our philosophical traditions we should say that the four-dimensional, integral, symmetrical origins of these multiple and contradictory shadows are real and that this reality is presented to us via its projections. We must break the habit of considering four-dimensional entities to be merely artificial constructs used in physics.

In the caves, we are forbidden by authority to turn and face the dancers directly, but in fact authority has no real power over us in this matter. We have the ability to see the dancers in their full dimensionality — to accept the cultivated experience of seeing the fourth dimension as being "out there," and it is our choice to do so. Failing to make this choice handicaps our ultimate understanding of reality. Our ability to apply four-dimensional geometry as a useful template for experience connects us to the multiplicity of spaces and points of view that implode upon us every day. If culture can teach us to see the third dimension as real, then just a little more culture can teach us to see the fourth dimension as real as well.

2.

Emotional Equations: Space in Mathematics and Art

If we lay out the history of mathematics alongside the history of art, we can see them move in step. No space, with its implicit mathematics, can be depicted in art before that space is known to mathematics; and it will not be long after a specific and detailed space is present in art that an analogous space will be formalized by mathematics.

William Ivins, Jr., in his 1946 book *Art and Geometry: A Study in Space Intuitions*, notices a long interval between the Greek style of illusionistic painting and the invention of Italian Renaissance perspective. In the frescoes and mosaics of Pompeii from the first century A.D., all the elements of perspective can be found: an established floor plane, the diminished scale of objects far away, objects foreshortened when turned toward the viewer, light and dark modeling of architecture and figures. Yet these formal devices do not add up to the Italian perspective of 1,300 years later; no one would make the mistake of confusing the two styles, though the formal devices of perspective are only those seen in Pompeii organized in a different way.

The same 1,300 years passed between the completion of static Greek geometry and the development of projective geometry, which begins the modeling of dynamic systems fundamental to all modern mathematics. In Ivins's example, one of Euclid's Porisms (mathematical speculations) discusses a triangle "swung" to make a second triangle, and the geometric relationship of these two triangles. Euclid discusses the obscure fact that the extensions of the three edges of both triangles meet on a line, in fact at the same three points on that line. But no classical geometer saw what Leonbattista Alberti, Blaise Pascal, and Gérard Desargues would later see: these triangles are sections of a single projected three-dimensional pyramid (figures 2.1, 2.2).

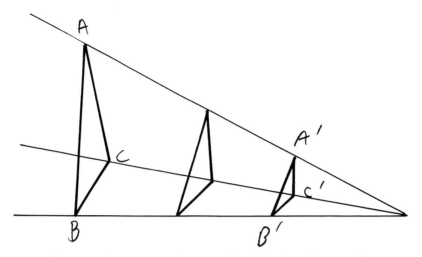

Fig. 2.1. Three triangles are sections of a pyramid, a simple three-dimensional fact which explains the way in which the three triangles are related.

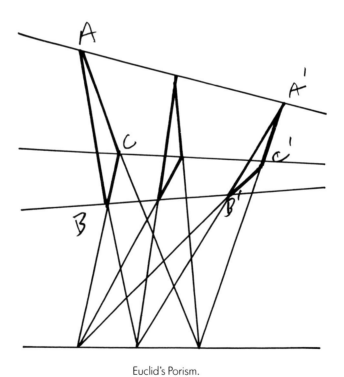

Euclid's Porism.

Fig. 2.2. The Greek geometer discovered many obscure relationships between two-dimensional figures, but missed even simple relationships between two- and three-dimensional ones.

Today, we would see in these parallel histories of art and mathematics the working of general "paradigms" of consciousness, after the influential arguments of Thomas Kuhn, the historian of science who has argued forcefully for the recognition of the subjective and political nature of scientific theories. Ivins, writing before Kuhn, refers to techniques of apprehension of space, which is a more specific argument. In ancient times, Greeks and Romans apprehended space with a tactile/muscular technique: space is known by passing through it along straight lines. Greek geometers could conceive of parallel lines that do not meet because that conception was based on human-scale experiences; for example, measuring the width of a straight and well-built road. Space was a manipulation of things, a measuring of things. Greek geometers could not conceive of parallel lines meeting at infinity, two infinite cones meeting at a point, or, in the example just cited, triangles projecting on a continuously tilting plane, because such things are not touched or measured but visualized. And visualizations, especially visualizations promoted by art, were suspect. In Plato's *Republic*, Socrates is discussing truth with Glaucon:

> Then that part of the soul, whose opinion runs counter to the measurements, cannot be identical with that part which agrees with them.

> Certainly not.

> But surely that part which relies on measurement and calculation must be the best part of the soul.

> Doubtless it must.

> Hence, that which contradicts this part must be one of the inferior elements of our nature.

> Necessarily so.

> This was the point which I wished to settle between us, when I said that painting, or to speak generally, the whole art of imitation, is busy about a work which is far removed from the truth; and that it associates moreover with that part of us, which is far removed from wisdom, and is its mistress and friend for no wholesome or true purpose.

> Unquestionably.

> Thus the art of imitation is a worthless mistress of a worthless friend, and the parent of a worthless progeny.[1]

Ivins notes that, from our post-Renaissance vantage point, Alberti is more accessible and more profound than Euclid. Alberti had a more general understanding, the vision of the three-dimensional pyramid, which encompasses more mathematical objects in the same system. Most important, his projective geometry leads to a mathematics of ordered infinitesimal change; its congruencies are fixed only for an instant. We can now see the plane sliding through the pyramid, leaving a series of related triangles in its path. The three-dimensional pyramid becomes a complete, static model of a dynamic, two-dimensional system, beginning to integrate time itself into the same mathematical system as space.

This power of visualization is a tremendous advantage. Consider the concept of interdependent masses and volumes in Alberti's S. Andrea in Mantua, designed in 1470. The deep-set facade alternates large solemn masses with large clear spaces for a powerful design, yet it is inside that the greatness of the building is felt (figure 2.3). Enormous open and uncluttered spaces are intersected by other open spaces. One feels the architect moving space and mass around equally to build his church; the building blocks are volumes, not planes or linear members. This was a structure fundamentally different from both classical buildings of vertical and horizontal bars and Gothic buildings based on interlocking lacework planes, which seem rinky-dink and frilly by comparison (figure 2.4). S. Andrea was a triumph in its own time and frequently copied (it was the model for Saint Peter's in Rome); it seemed then to be totally original and especially contemporary.

Alberti not only created the first of the Renaissance volume architecture but, as we have seen, also made the first systematic studies of perspective, as well as the first theorems of projective geometry. All three came simultaneously to the architect because they were all products of a new technique of apprehending space: by visualizing uniform, infinite, low-density matter. But how did Alberti arrive at such a profound new capability? I think the ability to visualize space comes with the understanding that air is a substance; designing volumetric architecture is like carving blocks of air. Renaissance painters had known for generations about atmospheric perspective — the diminishing of color of objects in the distance due to the substance of air — and thus air, not land, became their metaphor for space (figures 2.5, 2.6, 2.7, 2.8).

Given the difficulty of inventing a new technique of apprehending space, and given the unease about the world and ourselves that restructuring our vision

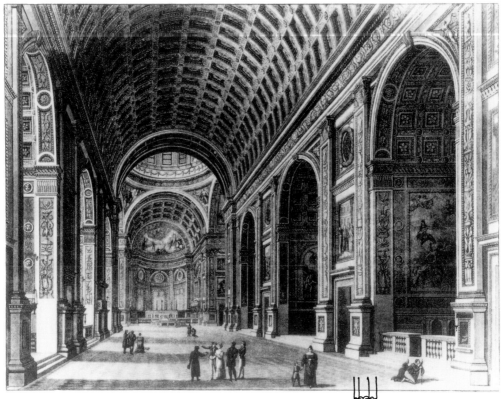

Fig. 2.3. F. L. Montini's *Interior of S. Andrea* conveys the feeling that architect Alberti sculpted his church out of blocks of space.

Fig. 2.4.

Gothic architects propped up lacework planes by intersecting them with other lacework planes.

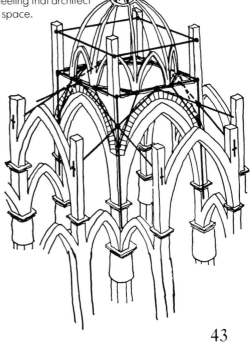

43

Fig. 2.5. In this Roman painting from Pompeii, the figures are modeled, foreshortened,
and rest on a ground plane, but there is no space in the painting.

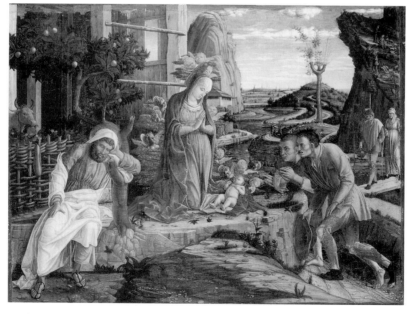

Fig. 2.6. Andrea Mantegna's perspective in *Adoration of the Shepherds* used no painter's tricks
the Roman artist did not use, but Mantegna did possess a different mathematics.

may induce, what is the motivation for incorporating a new space into our consciousness and accepting it as real? Ivins's theory is incomplete without this point of motivation. Only some cultural crisis, taken personally, could propel an artist to abandon the known world and agreed-upon language of communication. Imagine the desperation of knowing something, of seeing something important with your own eyes, that is absolutely impossible to communicate to your fellow human beings — the feeling, vague at first but eventually overwhelming, that you are not really experiencing the life you are living, and that your senses and thoughts are perversely filtered by precisely that which removes their essence.

Extrapolating Ivins's argument closer to our own time, we can look at Van Gogh's emotional message and the modern space in which it is manifest. No more articulate expression of Van Gogh's state of mind can be found than in his letters. Reading his letter about the painting *The Night Café* (figure 2.9), I am always moved by Van Gogh's vulnerability, and excited by his creativity. The letter seems to show us the very moment when expressionism was created.*

The Night Café is the Café de la Gare in Arles, which stays open all night and is a refuge for homeless people. Van Gogh has almost become such a person himself, out of money, the stipend from his brother late. Upstairs from the café is a rooming house where the painter now has a room. Rent money is "so much for nothing," as it would cost the landlord nothing to allow these broken and tired "night prowlers" a good night's sleep; not to do so is selfish and cruel. (We know now that sleep deprivation is a horrible form of torture and can induce psychotic symptoms.) Van Gogh has been hoping Gauguin will come to Arles so that they can share a place to live and have a permanent, affordable "home of my own." But Gauguin is touchy, unpredictable, and — according to previous letters — not too careful with money. Letters of this period constantly propose one scheme or another for permanent housing; not having a home "is bad when you have turned thirty-five." There is a free association of suicide at this point in the letter, all the more poignant because Van Gogh so quickly denies knowing anyone who could have done such a thing. And again at the end of the letter, Van Gogh returns to the question of the start-up costs of a permanent home and the question of whether or not he can afford it.

Van Gogh had a new emotion, and we should not be proud of this product of the modern era: a particular vulnerability, a feeling of isolation that sprang

*The letter is long; I include it in full in appendix 1.

45

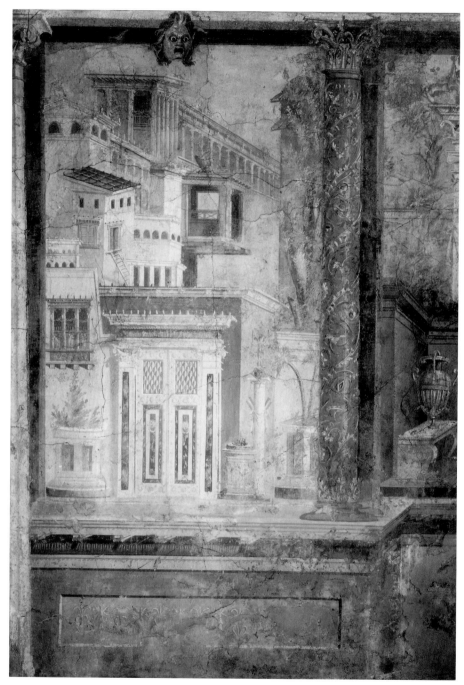

Fig. 2.7. This Roman painting of architecture uses overlapping planes, shading, and perspective convergence, but the artist does not seem to have the same commitment to making space as the Renaissance artist.

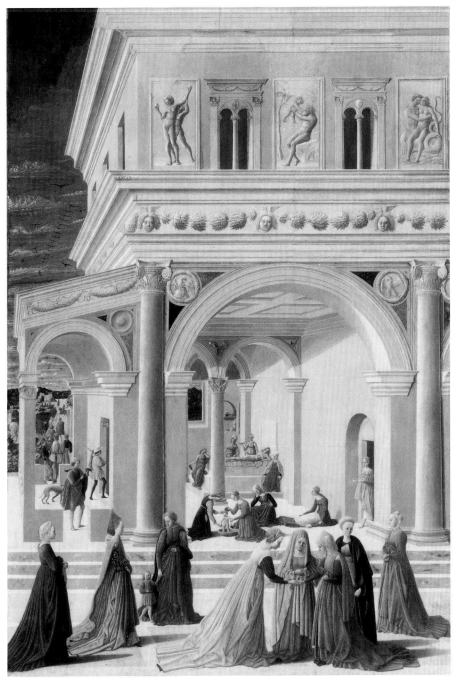

Fig. 2.8. The Master of the Barberini Panels has a few minor errors of perspective in his *Birth of the Virgin*,
but he has acquired a powerful sense of space that is more important to his purpose
than a collection of tricks of the trade perfectly used.

from the new freedom people had in the late nineteenth century to leave home, cut themselves off from the nurture of the local community, travel quickly to a faraway place, and attempt to re-create the security they had known — built from the investments of generations — instantly and from nothing. Such homelessness occurs far more rarely in the older culture of farming villages. The letter shows that this new emotion has motivated the painting.

Other parts of the letter show us a Van Gogh who is analytic, clear, and sure. He cites Delacroix and Hokusai as precursors of his experiments with exaggerated color and line, respectively. In the painting, the extreme clash of the colors expresses "terrible passions" and "emotion of an ardent temperament." In fact, they make the room into a "furnace"; it is Hell, and the erect white-coated landlord with the electric-green hair is the Devil. Most powerful of the Devil's instruments of torture are the lamps, floating free and not connected to the ceiling, with their thick rays of contrasting colors blowing away all human

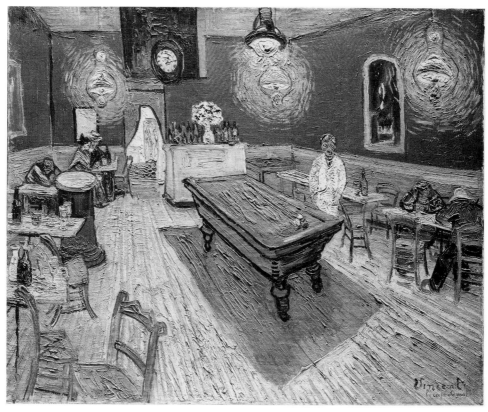

Fig. 2.9. Vincent Van Gogh's radiation-chamber space in *The Night Café* is the space of the electromagnetic field.

inhabitants. A month later when Van Gogh painted his bedroom, his refuge upstairs over the café, it is blue, clear, and open, exactly the opposite of this radiation chamber.

To create the metaphor of the torturous heat and light of Hell that prevent sleep, Van Gogh, as he says, "exaggerates line and color": breaking up the ceiling, tilting up the floor plane, stripping brush marks free from the things they represent, congesting the room with color and paint. We have come to call such formal devices expressionism; together they create a new space known as the field.

What an innocuous, feeble, and flimsy word *field* has become in formalist art criticism! But listen to how physicists talk about the field:

> No point is more central than this, that empty space is not empty.
> It is the seat of the most violent physics. The electromagnetic
> field fluctuates. Virtual pairs of positive and negative electrons,
> in effect, are continually being created and annihilated, and likewise
> pairs of mu mesons, pairs of baryons, and pairs of other particles.
> All these fluctuations coexist with the quantum fluctuations in the
> geometry and topology of space.[2]

The depiction is all the more aggressive when we learn that the last sentence refers to minuscule black holes embedded in every space. Although this description dates from 1970, the field as a physical concept was being codified by James Maxwell just at the period when Van Gogh was conducting his experiments with exaggerated color and line. Maxwell's concept of field, now a fundamental paradigm of physics, depicts a body enveloped in forces from every direction, a space thick with changing energy that resists freedom of movement, a substancelike emptiness capable of inflicting powerful force on a test particle.

The field is a mathematical space totally absent from premodern science, and totally inappropriate for premodern artistic expression. Premodern science considers space, but space is not the field. It is rather the Cartesian system of dimensionless points marking out a grid system that is a static, uniform, passive emptiness. In contrast, every point in the field contains pent-up motion defined by vectors (arrows expressing direction and magnitude), each of which is moving at odds with every other vector. The exact physical nature of the field is always under discussion, but appears to many to be packed particle upon particle, and it is anything but passive. In fact, the very definition of force is now completely wrapped up in the definition of the field, the mechanism of the transmission of

JOHN ARCHIBALD WHEELER tells a story of an event that could be his epiphany. During the Korean War, the destroyer he was on ran aground within range of a North Korean shore battery. The captain realized that there was no danger because it was low tide, at night, and there was a dense fog cover. High tide was at daybreak; before the sun could burn off the fog cover, the ship would float free of the sand barge, allowing it to safely slip away. All that was required were silence, patience, and steady nerves. Unfortunately, a series of mines began floating past the ship; just one blast would alert the shore battery. Even the conventional response — shooting at the mines to explode them far from the ship — meant that they would be literally dead in the water. The captain brought all hands on deck and explained the situation. Any suggestion, by anyone, would be respectfully entertained, he said. No one will laugh; that's an order. One shy seaman finally stammered out his idea: everyone would go to the side of the ship where the mines were and blow — maybe they could blow them away. Of course this silly idea would not work, but the captain realized that the principle was sound. The fire hoses were turned on the mines, which were swept behind the ship, and at dawn the ship sailed silently away.

America's foremost relativity physicist lives by that lesson of humility. He has learned enough about the universe to know that it is far stranger than physics ever thought possible. In the last chapter of the college text — *the* text of general relativity — that he cowrote with Charles W. Misner and Kip S. Thorne, physics humbly bows before the Upanishads. And long before that two thousandth page is reached, the consistent style of the book urges the reader to let go of all preconceived ideas, no matter how basic and commonsensical they appear. That our point of view is privileged is the ultimate hubris; both general relativity and cosmology prove it wrong. From hearing Wheeler lecture and talking to him, I think he really wants each one of us to live by what physics teaches: everyone's ideas are important, because no frame of reference is primary, and everyone has the perpetual experience of interacting with existence at the most fundamental level, making quantum events happen by observation.

The philosophical implications of Einstein's famous $E=Mc^2$ are now accepted. On one side of the equation, Wheeler would say, is energy, and on the other side is matter. That is to say, we really believe that matter and energy are equivalent and interchangeable. We accept that everything is made up of nothing but whirling bits of energy, and that even the

force via minuscule local events, rather than the more pristine (and philosoph-
ically unsatisfying) actions at a distance that can only take place in space.

No similar field space existed in art before the codification of the electro-
magnetic field, nor was it appropriated by an artist as a purely formal improvi-
sation. Rather, the field was needed as a formal device by Van Gogh when
circumstance compelled him to take one of culture's problems personally,
needed because this problem was a big new problem that could not be shoe-
horned into a comfortable old cliché. Van Gogh's new emotion could only be
expressed and thus brought into being by a new space.

But this new field is still not the space of our contemporary experience, for
it cannot begin to encompass our visual experience in the late twentieth century.
While only five or six generations ago, a mere eyeblink in the evolution of the
human species, a viewer might see a few hundred pictures in a lifetime, now a
viewer sees thousands every day, on buses, buildings, and roadsides, in maga-
zines, newspapers, and books, on television and in films. All these images
(which advertise, entertain, inform) are acausally collected at a time and place
without smooth transition.

Television, in cultural critic Marshall McLuhan's sound-bite vocabulary, is an
emblem that stands not just for itself but also for telephones, movies, laser
disks, fax, and even air travel; it stands for the ability to take our vision out of
our time and place, and to ignore the corporal support of consciousness. In his
writings, but most effectively in his television specials, McLuhan argued force-

smallest lump of earth has vast explosive power, if it could all be unlocked.
Wheeler also encourages us to accept the philosophical implications of
Tev=Gev, the great equation of general relativity. On the left side of the
equation is the mathematical instrument that defines space-time, and on
the other side is everything else — mass, energy, momentum. Space-time
is equivalent and interchangeable with everything; we are not made up of
bits of whirling energy because they are made up of space-time. Of these
two — space and time — it is time that turns out to be the most obdurate,
and space the most flexible. Time drives space to bifurcation and convo-
lution, more than the other way around. Last I heard, Wheeler was still
caught up in that humbling mystery.

fully that the medium of communication most used in an age penetrates deep into our psyche and changes us in ways that are hard to recognize. In the Middle Ages people had medieval dreams — dreams based on the models provided by the myths, literature, and images of that time. For McLuhan it is not the degrading, sappy sitcoms or even the personality-smeared news programs that make television potent; rather, it is the ability of television to extend our eyes — to put our awareness in that hand-held camera in the Persian Gulf or under the surface of the ocean with Jacques Cousteau. Such experiences have the most profound effect on our sense of our own bodies, the unconscious images that we use to make accommodations with our experience. Watching television is like exploring wormholes* where every point in space, say your television screen, has the potential to be connected to every other point in space without passing through the intervening space (figure 2.10).

Fig. 2.10. Wormholes in physics are often depicted by drawings like this; two essentially discontinuous spaces are pinched together.

There exist, then, both the opportunity and the necessity to search for a structure of space that is multiple, simultaneous, paradoxical, impossibly convoluted, discontinuous, yet multiconnected, with mutually exclusive components. The opportunity exists because there are intimations of such a space all around us; the necessity, because we must make sense (in both meanings of the term) out of our experience of space.

For example, it is hard to imagine a space in which quantum effects could occur. The most gripping experience of quantum effects is that presented by the Bell inequality experiments, also referred to as delayed-choice experiments because events are influenced by causes that have yet to take place, causes resulting from choices not yet made. In other words, some particles seem to know in advance how the dice will fall and in what kind of experiment they will be participating; they know before the experimenters cast the dice.

As Bernard d'Espagnat explains it, in 1935 Albert Einstein, Boris Podolsky, and Nathan Rosen developed an argument to demonstrate the absurdity of quantum reality. They posited that some day it will be possible to build the following experiment: particles are created in pairs — both A/B and C/D pairs. The elements of each pair are separated, and one is quickly placed in a storage ring for later viewing; the other is sent down a long, long tube. At the end of the tube a physicist sits flipping a coin. If the coin comes up heads he looks for A/B pairs, and finds either an A or a B, with the corresponding other half of the pair cruising around comfortably in the storage ring. But if the coin comes up tails, the physicist sets up different equipment to look for C/D pairs, one of which will be discovered at the end of the tube and the other of which was earlier placed in the storage ring. In other words, the particle in the ring knows, even before the coin is tossed, in which experiment it will be participating. In 1964 J. S. Bell completed theoretical work that allowed such experiments to be built, albeit in a slightly more diffuse fashion than they have been described here. The results are as predicted: the Einstein-Podolsky-Rosen thought experiment is brought to life; the results are absurd yet unmistakable.

D'Espagnat has argued that the Bell inequality experiments force us to

Wormhole is a concept from physics; real wormholes do exist at the quantum scale: particles can "tunnel" and suddenly be somewhere they could not be if they had to travel there through regular space. On those occasions the next place in space is one far away. Moreover, the extreme curvature of space was, at one time, thought to produce wormholes of large size, and so it is fair to use them as a metaphor for the space of television and the space of our experience in general.

choose between two difficult alternatives: (1) that, in violation of the special theory of relativity, information and physical effects can travel faster than the speed of light (which is tantamount to saying that time flows backward in some circumstances); or (2) that spacelike separations do not always exist when expected (which is like saying that the observed does not always exist until there is interaction with the observer). D'Espagnat finds the former easier to accept, but is it really?

Erwin Schrödinger's famous cat demonstrates how unsatisfactory either alternative is. A cat is locked in a box over the weekend with a poison-gas pellet triggered to go off, or not, due to some quantum trigger which has a 50 percent probability of firing. When the scientist opens the box on Monday morning either an angry live cat jumps out or the cat is dead and beginning to decay. The problem is that neither case is the fact until the box is opened; quantum events hold in existence all their states of fact until observed. Either time runs backward (the cat begins to decay, then it dies, then the poison is triggered) or two separate cats in two separate boxes with different fates are in that box all along and only one remains when the box is opened. Some physicists actually refer to the universe splitting into two universes each time such a quantum effect is observed, with the probability of you and I being in one or the other universe a probability of the quantum effect.

Bell inequality experiments are being repeated in numerous places (most recently by Alain Aspect at the University of Paris's Institute of Optics), in ever more concrete ways, in ever larger scales, though not yet at the cat level. Clearly no space or space-time explanations of them are possible.

Something must be very wrong with our geometry of space if it is inadequate to describe either our subjective or objective contemporary experience. We are on the verge of a new space, neither the rigid empty solid of the Renaissance nor the filled, aggressive field of the turn of the century, but one very different from both. The new space is pressing upon us in both art and mathematics, as both artists and mathematicians try to overcome the inadequacies of our previous models of space and to formalize their unconscious images of space (images based on McLuhan's "television"). In physics more and more of the new models of quantum wormhole space are derived from the ability of physicists to visualize and work in a space of four dimensions, as we will see in chapter 6. No such proposal is dogma yet, however; as even the proposals that work best do not include gravity, it is still very much an open question. As

culture teaches us to heal the cut in consciousness and to experience the new subjective world whole (using mathematics as a guide), the four-dimensional world will become more real to artist and physicist alike. It is then that the true four (or more)-dimensional model of wormhole space will become manifest.

The startling conclusion of the argument of this chapter is that neither the mathematician nor the artist is free to make progress in his or her respective formalisms without the other. Hidden in every newly discovered equation is a new emotion, for each algebraic scribble is really the coding up of a new concept of geometric space, and it is the concept of space that is the substrate of our emotions. Perhaps this constitutes a new definition of artists, demoting them to applied mathematicians, or mere illustrators of science. "Applied mathematician" and "mere illustrator" are terms that hush children and make brave adults swallow, but I think contemporary artists, if they accept their subservient position (noting that it was good enough for the likes of Masaccio and Van Gogh), can have the privilege of taking part in the great revolution in mathematics going on around us. The enrichment of geometry through computers and new disciplines like topology and fractals, which capture the chaotic and the amorphous, makes this period, right now, a time of magnificent discovery. Some say, If only I were in the Florence of Masaccio, in the 1420s, or in Bern in the first decade of the twentieth century when Einstein was working; but people will soon be saying that about the last decade of this century.

And notice that such a definition gives artists credit not just for the discovery of a new style, a new package for the same age-old emotions, a new spin on the timeless human predicament, but for the discovery of new emotions. I really cannot imagine — and there certainly is not the slightest evidence for it — that people sitting around in Greek kryta experienced landscape in the way the impressionists would come to see it, flooded by the disconnected sensation we see in Monet. We must fight against the conceit that all peoples, at all times of history, saw the world just as we see it now. Art history tells us differently. Nothing about us is static. A hundred years ago an influenza epidemic decimated a population, but not now, because we have evolved a resistance to that disease. Humans continue to evolve physically, immunologically, linguistically, politically, and emotionally.

Too little credit is given for these emotional discoveries; they are not just the whipped cream on the necessarily more robust nutrients of life. For one thing, hidden in every new emotion is a new worldview, and eventually a new math-

ematical theorem. What blocks theoretical scientists and mathematicians from making more discoveries? Not every intelligent and well-educated theoretical scientist or mathematician makes important discoveries. Sometimes we say that the discipline was not mature, or was too mature, when such and such a person lived, so naturally the big discovery had to wait another hundred years. But the pieces are always in place to make the next big discovery, and too many times it is not made by the most learned, or even by the most intelligent, as judged by standards such as examination grades.

I believe the seeds of mathematical creativity are the same as those of artistic creativity: some crisis of cultural awareness that the mathematician takes on in a personal way, an emotional self-expression to complete a personality. Scientists and mathematicians do not work outside of culture. Jules-Henri Poincaré, the father of topology, is the same man who embraced the frightening fin de siècle worldview, the malleability and plasticity it articulated, including the emotional consequences of a world without absolute, transcendent values. His writings at the turn of the century are filled with the word "relativity"; it is plain he had a taste for the ambiguities of the time. What propels or blocks mathematicians, then, is their willingness to experience a new emotion, or see the world with a new aesthetics. Perhaps it is fair to say that mathematicians are mere practitioners of the applied arts.

It's reciprocal. Mathematicians must wait for artists to make them ready for their discoveries, and artists must wait for mathematicians to give them the means to make our experiences in life sensible and acceptable to us. If artists mine the territory and exploit the riches that mathematicians stake out, artists are also the provisioners and the bankers of these prospector mathematicians. It is often remarked that it is astounding that culturally biased, transient human conceptions can be so mysteriously effective in describing the objective world. But I think the converse is no less astounding, that the new world out there, discovered by mathematicians, penetrates so deeply into our souls and becomes fundamental to our emotional life.

3.
Chinese Boxes and Shadows from Heaven

During the Albert Einstein centennial year, 1979, a great convocation of physicists met in New York to consider Einstein's influence on contemporary physics. Artists were interspersed among the scientists; Bill Conlon, Richard Friedberg, Fred Guyot, and Al Held were all there, among many others I knew only by sight. The great physicist P.A.M. Dirac was in the hall, and John Wheeler and Dennis Sciama spoke. This was far more thrilling than any art world event that year. This was the nature art should imitate, and these physicists were the people who knew about space.

In part, the course had been set years earlier by Jacob Bronowski in his book and television series *The Ascent of Man*, which was attentively studied and discussed by my artist friends when first aired. Bronowski sought the underlying concepts of science. He emphasized the importance of these paradigms over their formal expressions or their applications, and he was equally at home using art or science to illustrate these concepts. It seemed to be his most ardent wish that these concepts — now considered so fundamental a part of nature — be understood to be human creations. The prejudice that scientists discovered preexisting laws *from out there* while artists created expressions *from inside* had begun to break down.

Bronowski's illustrations confirmed William Ivins's idea about "space": that it *was* a human invention, not an objective truth, and, like all inventions, could become obsolete. I articulated this idea in the English art magazine *Artscribe:*

> When we consider space itself, we soon come to an overriding realization: space does not exist/ there is no such thing as space/ space is only a mental concept. . . . Since space does not exist, and people cannot usefully conceptualize about nothing, they invent space as though it does exist. People think about space metaphorically as though it were a thing, as though it were like rods, or sheets of paper, or air.

> The metaphor of space totally conditions not only our ego-
> centric experience but our objective understanding of the physical
> universe as well. It has happened before that the coeval metaphor
> for space cannot be made to fit subjective or objective experience,
> and individuals have invented new metaphors.[1]

John Dee, the English artist and scholar, in commenting on this article and the exhibition inspired by it that he curated, reiterated the claim that the first step in developing a more effective paradigm of space and thereby liberating expression was to understand that the ossified metaphor we use for space is a cultural and linguistic artifact.

> The Euclidean space that our minds normally comfortably inhabit
> was constructed by artists five hundred years ago. Nobody formed
> the picture of space as something capable of existing without
> objects, as the pre-existing container of everything else, until the
> Renaissance. The very word "space," even to describe the more
> primitive concept of the gaps between objects, did not come into
> common English use until the fourteenth century.[2]

John Dee and I had Jules-Henri Poincaré and Albert Einstein to back us up:

> The geometric language is after all only a language. Space is only
> a word that we have believed a thing.[3]

> Is the Euclidean geometry true? It has no meaning. As well ask
> whether the metric system is true and the old measures false. . . .
> One geometry can not be more true than another; it can only be
> more convenient.[4]

> When a smaller box s is situated, relatively at rest, inside the hollow
> space of a large box S then the hollow space of s is a part of the
> hollow space of S, and the same "space," which contains both of
> them, belongs to each of the boxes. When s is in motion with respect
> to S, however, the concept is less simple. One is then inclined to
> think that s encloses always the same space, but a variable part of
> the space S. It then becomes necessary to apportion to each box
> its particular space, not thought of as bounded, and to assume that
> these two spaces are in motion with respect to each other.
>
> Before one has become aware of this complication, space appears
> as an unbounded medium or container which material objects swim
> around. But it must now be remembered that there is an infinite
> number of spaces, which are in motion with respect to each other.[5]

58

Einstein's example is deceptively simple, for once *space* sublimes, leaving behind *spaces*, more and more complications follow. Because the speed of light is constant in all frames of reference, and in order to have the laws of physics be the same in all parts of the universe (the very least rule of science imaginable), these boxes of space (sometimes called coordinate systems, CSs, or frames of reference) have to become fundamentally discontinuous, even though they may overlap. Clocks in them run at different rates and measuring rods shrink to different lengths; the spaces become spaces with different metrics. Two events that are simultaneous in one space happen at different times when seen from a different space, and living human beings could conceivably become wider in the middle than they are tall when seen from different CSs.

Herman Minkowski, Einstein's former mathematics teacher, fit this new physics into a geometric system of "invariance," and the result is the four-dimensional geometric formulation of the special theory of relativity that we learn today. Thus, special relativity was intended to be seen as four-dimensional geometry almost from the beginning, and focusing only on physical phenomena (rulers shrink; time is the fourth dimension) obscures its essential value.

Dee offers Claude Monet's *Water Lilies* as an example of what powerful creative energy can result from the concept of multiple spaces. He discusses "the shimmering veil of three distinct spaces": the surface of the water on which part of the lily pads float, the space below the surface of the water where we can see other parts of the water lilies, and the sky of clouds reflected from the pond's surface (figure 3.1). We are invited to see all three spaces at the

Fig. 3.1. Monet's *Water Lilies* puts multiple spaces in the same place at once, according to John Dee: the sky, the water's surface, and underwater — as well as the paint on canvas.

same time. Successive works eliminate more and more spatial clues (the strip of shore, the peripheral vision of the edges of the canvas) so that the viewer is inexorably brought into and loses himself in this vortex of sensation. To confuse one space with another becomes a magnanimous act of seeing.

Monet's lesson is to build paintings where more than one object is in the same place at the same time, where the viewer is in more than one place at the same time, and where there is no ground. From this point of view, Monet's late paintings are not the last vestiges of an out-of-date impressionism; rather, they are the completion of cubism, which firstly and incompletely presented such a space.* From this point of view also it is the spatial properties, not the color and brushwork, that make Monet's later work so appealing and enduring.

I can remember the moment when all these philosophical considerations suddenly became real to me. It came after an intense period of painting, writing, and studying four-dimensional geometry. I walked past an area where incandescent bulbs shed yellow light into my loft and toward the windows, which let in blue winter light. I had seen it before thousands of times, but just this once the yellow light seemed incredibly yellow and the blue incredibly blue in the same space. In thinking later about that experience, which was powerful and threatening to me at the time, I realized why the yellow had never seemed so yellow, nor the blue so blue. I had been discounting my experience, pretending a little not to see yellow and blue, out of a desire to be faithful to Euclid. A three-dimensional rectilinear solid can have only one volume of air and light in it. But Euclid and three-dimensional space are arbitrary artifacts, as Poincaré has emphasized. In particular, three-dimensional space is not able to house the rich multiplicity that we know exists in relativity. Being faithful to Euclid separates us from our experience, not only in science, but in aesthetic seeing.

It was soon after this experience that I knew how to make art out of these ideas; soon after that I saw the fourth dimension on Banchoff's computer; and within a few years more, I was writing my own programs of four-dimensional geometry.

These programs teach us to construct a hypercube as follows: Start with a

*After World War I, Picasso in particular returned to narrative paintings treating the humanist themes of the nineteenth century — such as the artist as the Noble Savage — thus taking himself out of the running as champion of the search for a new space, and retrofitting cubism as another form of expressionism.

line. Move this line in a direction perpendicular to the line one unit-distance (the same distance away as the length of the line). A square is thus defined from the starting line, its displacement, and the two new lines that have been created. Now displace this square one unit-distance in a direction perpendicular to the edges of the square. In doing so, a cube has been defined: the starting square, its displacement, and four new squares that have been created make up this cube. If the cube is to be confined to a page, some of those squares will be skewed; but that is just a matter of representation — they are in fact all identical squares. Even with this distortion of shape, the convention for portraying a cube on a two-dimensional sheet of paper is mysteriously effective. The placing of the third perpendicular so that it appears to lie between the other two on the same plane surprisingly provides the visual information needed to see the cube. Now move that cube one unit-distance in a direction perpendicular to each of the three perpendicular edges of the cube. The entire cube is extended in a direction that is mutually perpendicular to all the edges meeting at a corner. The cube and its displacement extrude six more cubes, so that the hypercube has a total of eight cubes, now called cells of the hypercube. Even though some cubes may be portrayed skewed, they are all identical and are all perfectly regular cubes. In the convention, again mysteriously effective, for portraying this hypercube on a two-dimensional surface, the fourth direction is placed perpendicular to the third, even though the third no longer lies perpendicular to the first and second (figure 3.2).

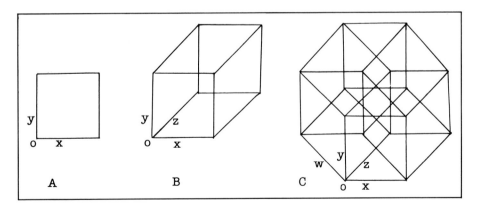

Fig. 3.2. The generation of a hypercube from a square. Move the square "back" into the third dimension to make a cube; move the cube "back" into the fourth dimension to make a hypercube.

THOMAS BANCHOFF is a churchman; with his Anglophilia, especially for the Reverend Edwin Abbott Abbott, the author of *Flatland*, I think of him as an Anglican vicar, gray and gaunt. Forthright and dutiful, Banchoff discharged his responsibilities faithfully for many years as chairman of the mathematics department at Brown University. He is the author of solid, helpful texts. He returns even long-distance calls to people he does not know. Far from considering teaching a corrupting burden, he likes it. Banchoff is just the man to take on the aggravating but necessary chore of putting together an academic conference commemorating the hundredth anniversary of the publication of *Flatland*, which he did. The aforestated notwithstanding, Banchoff's kindness is genuine and personal, as well as dutiful and formal; he is a vicar with a human face. He spends time with sick friends, and takes on people's troubles as though they were his own.

Banchoff's personal qualities made him ideally suited to the pioneering work for which he is known: the implementation of computer graphics in mathematics. Especially in the beginning, nothing requires more patience, forbearance, and diligence than getting those clunky, temperamental, and gigantic machines to do a little mathematical plotting. One has to share authority with programmers and electrical engineers — those lesser priests of heretical faiths, to mathematicians — not to mention doing a lot of voodoo. The damn things even have to be turned on in the right order. I saw a year go by while the switch from vector graphics to raster graphics was taking place; a year to teach a computer to fill in a plane with color rapidly. What a comedown, for a mathematician to be subservient to a cranky machine. One can be sustained only by faith during such trying times.

Banchoff's faith *is* an old-time religion. He wanted to visualize higher-dimensional, complex spaces. Visualization has a long and noble tradition in mathematics and physics. A mathematical truth, historically, was not real unless you could see it; order, symmetry, and structure are mathematical qualities that only the eyes can apprehend fully. But by the time Banchoff began working with computers in the late sixties, visualization had long been put to rest as an antiquated mathematical skill. Indifference, if not ridicule, from the mathematical establishment was Banchoff's reward for attempting to revive this virtue.

Now, however, things are different; the computers are different, of course, but so are the attitudes. Even the most abstract geometries are

Computer simulations are often thought about in metaphors of optical instruments: telescopes to witness far-off (and early) states of the galaxies; microscopes to see increasingly finer details in fractal structures; windows into strange worlds. But I began to think of my four-dimensional programs with a different imagery, one that allowed me to make an easier transition from computer graphics to works of art. I began to see the shadows of four-dimensional objects, which were behind my head, projected onto the computer screen in front of my eyes.

Banchoff's program revives the distinction, explained below, between mathematical slices and mathematical projections. This distinction was made in nineteenth-century mathematical discussions, though without computers to depict projections, most thinkers visualized and worked only with slices. For professionals who work with algebraic formulas exclusively, the distinction between slices and projections is all but lost. But the distinction is critical for using four-dimensional geometry as a template for experience. Projections are

researched — not demonstrated, mind you, but researched — on computers that produce visual output — pictures. People talk more openly and confidently about seeing spaces of even eleven dimensions. Sometimes it is the equations that are impenetrable and ambiguous, while the pictures are clear. Now they come to Banchoff for advice on how to do mathematics with computer graphics.

Banchoff's introductory lecture about the fourth dimension includes a slide of a frame from a comic book, which was his first exposure to the idea of higher dimensions. That the comic book is still with him is significant, because I sometimes see the little boy in the vicar's robes. We can probably all remember the childhood thrill of knowing an esoteric secret, a special list, a bit of knowledge with magical properties. It is a great pity for Banchoff that he was born forty years too early for Dungeons and Dragons; he could have been a great Dungeon Master. Knowing the hidden locations, cataloging the mysterious properties, sloughing off ignorance and danger, acquiring the magical perception — this could have been Banchoff's destiny. Instead, he must make do with learning to see the fourth dimension, and visualize complex variables. That he can make a living at this child's play must seem an absolute scream.

all that we see; by the time the image of a tree, a person, or a car reaches our eyes it is a flat wavefront of light projected from that object. No one far from a sawmill sees a slice of a tree.

To understand slicing, imagine dipping a chair into a swimming pool. At first only the four legs are wet; a two-dimensional slice of the chair is a group of four circles. Then the seat hits the surface of the water, and our two-dimensional slice is a square. When the back goes under, the slice is a thick line. Thus one two-dimensional manifestation of the chair is a series of disconnected slices, rather hard to assemble in the mind's eye into a chair. That is, suppose only these slices were available, and no chairlike object were known. Even if the slices were flashed quickly before your eyes, could you see a chair? Most early techniques for visualizing hypercubes and four-dimensional objects, including the influential ones of Charles H. Hinton and Edwin Abbott Abbott, attempted to use a dynamic system of three-dimensional slices. And this limited technique, unfortunately, was all that was available to early modern artists.

There is, however, another way to capture a chair on a two-dimensional surface, and that is to shine a light on the chair so that the shadow falls on a flat surface. This shadow projection is distorted in its angles, but, as we have seen, that distortion makes surprisingly little difference to the mind's eye. All parts of the chair are present at once, and we can easily distinguish the chair from its shadow alone. Topological (or surface) continuity is preserved in projection, and continuity seems most important for vision. If the chair is rotated while we observe the changing shadow, the chair can spring to life as a rigid object; the visual information necessary to see the three-dimensional object is unambiguously available in the dynamic two-dimensional display (figure 3.3).

Fig. 3.3. A projection and a series of slices of a chair. Even a mixed-up projection of a chair is more of a chair than a collection of perpendicular slices.

I have a thought experiment that stresses the importance of making the distinction between slices and projections. First note, however, that traditionally in relativity physics, four-dimensional space-time is divided into three-dimensional space and one-dimensional time by slicing; physics books tell us to *take a hyperplane slice of simultaneity*. Although slicing is a purely mathematical operation, it is often visualized in a concrete way by thinking of slices as pages in a book: each page represents a three-dimensional space and the pages are stacked orthogonally (in a direction perpendicular to each of the edges of the page) to make up the book of space-time. (Or remember that dipping the chair into the swimming pool is a two-dimensional slicing of the three-dimensional chair.) This slicing of space-time to yield space and time is a hidden assumption. My solution to the mysteries of space-time is that space-time is better thought of as being divided into space and time by projection. As the purely geometric operation of casting a two-dimensional shadow of a chair maintains the topological properties of the chair, projection of the fourfield results in a three-dimensional space with the connectivity of the full four-dimensional entity. The residue of this projection — like the residue of the slicing — we experience as time. Moreover, these projected figures have in themselves "physical" properties that otherwise must be added to space-time as unwarranted extra conditions.

In this thought experiment (figure 3.4), physicists are conducting an experiment with a birdcage covered by a black drape.[6] The birdcage is at the axle hub of a large wagon wheel, and around the rim are a number of receptors. The experimental physicists are communicating with us over a telephone and asking us to interpret their data. They say, "We are getting data in ordered sequence. We can spin our receptors around the birdcage. Depending on how we do this, we can freeze the sequence on one receptor, or spinning the wagon wheel faster makes the receptors fire in a backwards order." We reply, "We think you are observing a rotation in space. Imagine a gun rotating inside the birdcage shooting signals to your receptors."

They conduct another experiment and report, "On this occasion our ordered sequence of signals is unaffected by the rotation of our receptors around the birdcage. If we turn our receptors off for a while, no matter how we displace them in the interim, we can never pick up the sequence where we left off." We reply, "We think you are observing the passage of time. Imagine an hourglass in your birdcage. Each 'time' a grain falls, a signal is sent to your receptors."

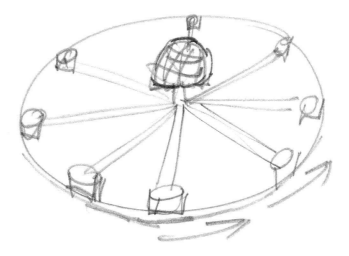

Fig. 3.4. A birdcage set on a giant rotating wagon wheel.
Receptors are set on the rim.

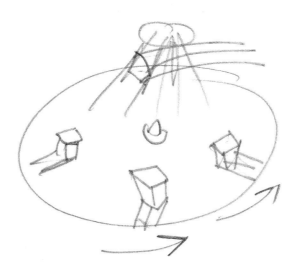

Fig. 3.5. The shadow of cubes on a giant rotating turntable.
Most of the shadow rotates around the cube, but the shadow just under
the cube is at rest relative to the cube and in motion relative to the rest of the shadow.

A third experiment is conducted that bewilders them because it behaves both like a rotation in space and like the passage of time. Although the informational results of a rotation in space and the passage of time appear initially to be distinct and mutually exclusive, this experiment unmistakably has the informational results of both.

Now a theoretical physicist with us says to the experimenters, "You are observing a space-time phenomenon; you can learn to consider space and time to be part of one algebraic system so that influences on one part are collected by the whole system and observable in a quite separate part." But I reply, "You are observing the rotations of a hypercube as it is projected into three-space; parts of it rotate with you and parts of it do not."

To see how this is true, consider the three-dimensional case. Imagine a giant turntable on which you stand and observe at close distance an open metal cube (figure 3.5). A stationary light casts a shadow of the cube at your feet. As the turntable begins to rotate, the shadow of the metal cube begins to rotate around the cube, though you and the cube are at rest relative to one another. Now consider the part of the shadow just underneath the bottom of the cube. This square must be considered part of the shadow (all of the metal edges of the cube block out light); yet this part of the shadow is at rest relative to you and in motion relative to the other parts of the cube's shadow. Though this is the shadow of a rigid Euclidean object, parts of it rotate with you and parts do not. We could also walk around the cube as the turntable rotates and reverse the relative motions.

In the birdcage experiment we have a higher-dimensional analogue of the turntable. The space of the experimental physicists is a continuation of one cell of a hypercube, represented by the birdcage. The rest of the hypercube is projected into this space. There is rotation of the hypercube, and parts of the projection rotate with us as we move around it, and parts do not. Thus the informational content of the space-time continuum is produced by rotating projections of the hypercube to three-space: time is the same for all directions, but space marks different angles.

The least we can say as a result of this thought experiment is that the situation we call time is informationally isomorphic to what I call the fourfield: every point in three-space has a continuation orthogonal to that three-space, and the fourfield is manifested in three-space in such a way as to be partially unaffected by transpositions in three-space while continuously maintaining its

geometric integrity. The most we can say is that only *projections* of the fourfield can be such a manifestation because only projections of the fourfield have the geometric property of being able to partially rotate and partially remain fixed in three-space while preserving their geometric integrity. Space and time might be adequately modeled in a fourfield that is sliced to render space and time, but genuine *space-time* must be modeled in a fourfield that is projected to render space and time.

I am convinced that the choice of projections of space-time over slices of space-time, which must be made on purely philosophical grounds, has advantages for the physicist as well. In an article published in *Leonardo*, I set about articulating three advantages. First, the purely geometric act of projection imbues a line with metric properties that are distinct from mere slices, the same "contracted" metric properties observed in special relativity (figure 3.6). Second, projected geometric figures have a double-back topology; a 360-degree rotation around them may return one to the original location but in an upside-down position, so that another 360-degree circuit is required to return home in the correct orientation (figure 3.7). Particle physicists tell us that physical space has this 720-degree property. Finally, the most mysterious property of physical space — that quantum effects can occur in it — sometimes may be more comprehensible to us if we model space-time in four-dimensional projected figures, for in a projection all parts of the figure are retained in a topological continuity.

Projection does something radical and irreversible to the figure as a whole, defining one direction as distinct from the other three; a spatial present and a temporal past are both made manifest by the same mathematical operation. Independent of my arguments, four-dimensional geometry without projection is proving more and more useful as a tool to depict quantum events, and a few physicists have begun to consider projection spaces (see chapter 6). It is very possible that our difficulty in depicting a space in which quantum effects can occur may be due to our rigid and unquestioning adherence to the notion that space-time is divided into space and time by slicing rather than projection.

I have been describing geometric objects that partially rotate when you walk around them and that seem partially impervious to such movement; that seem to rotate with you so that your movement leaves these parts unaffected. As I mentioned in chapter 1, I have developed ways to make artworks that rotate in

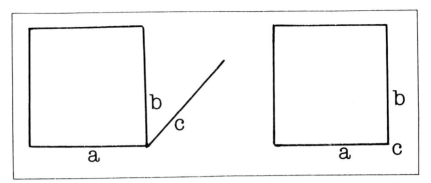

Fig. 3.6. Metric properties of a fully projected figure are revealed by considering both of
these drawings together: there is a line c, but it cannot be measured in units of a or b.

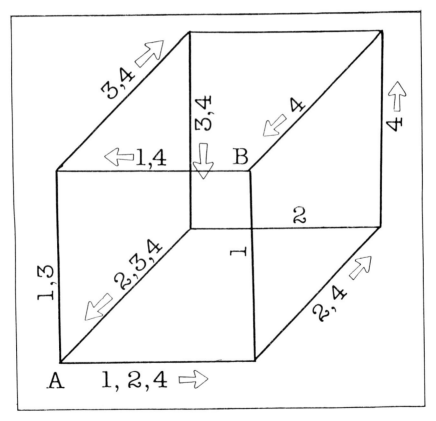

Fig. 3.7. Paths around a cube projected on a plane;
not every 360-degree circuit returns home.

this way. If I am right about projected four-dimensional figures in physics, then these planar-rotation works of art imitate nature in the most profound sense, and may teach us about the ultimate description of nature as pure geometry.

Another form such an artwork could take is a hypercube sundial (figure 3.8). This piece would consist of a skeletal cubic structure (cells of hypercubes) rising from a stone platform inlaid with a special pattern. The sun casts shadows of the three-dimensional cells, making patterns that coincide with the inlaid patterns. As the sun moves, the shadows coincide in different ways with different parts of the inlaid pattern, telling time. At noon, for example, the central element completes a planar rotation such that two cells of the hypercube dissolve into a single cell.* Only rays of light from the sun that are parallel to each other reach the earth; the others diverge over the long distance to the earth and miss us. This column of parallel light rays allows for a perfect isometric shadow projection (the kind the computer generates), which is not possible from a point light source such as an interior spotlight, where the shadows are always bigger than the objects from which they derive.

The first computer images of hypercubes were created by Michael Nöll at Bell Labs in 1966. An important feature of Nöll's program was that it employed stereo vision. Two images were given side by side, and by crossing the eyes a three-dimensional image of the four-dimensional projection could be seen. As I mentioned, Von Foerster thought stereo vision was essential, and included in his four-dimensional training system a binocular scope where each eye looked at a different computer monitor. Banchoff abandoned stereo in favor of real-time interactive manipulation of the hypercube with a joystick, but David Brisson, an artist also working in Providence, thought stereo was important. Brisson built three-dimensional wire models of hypercubes, painted them red and green, and viewed them with the anaglyph glasses familiar to readers of 3D comics. For my system I wanted both real time and 3D, but I have trouble with the crossed-eyes type. Fortunately, by the time I built my system in 1983 computer technology had progressed to the point where I could have anaglyphic stereo, drawn in perspective, in real time.†

*At different times of the year the noon sun will reach different heights in the sky, but these effects (±11 degrees) are minimal and do not interfere with the patterns discussed.

†Anaglyphic stereo is a feature of the programs released with this book, if a color system is used.

70

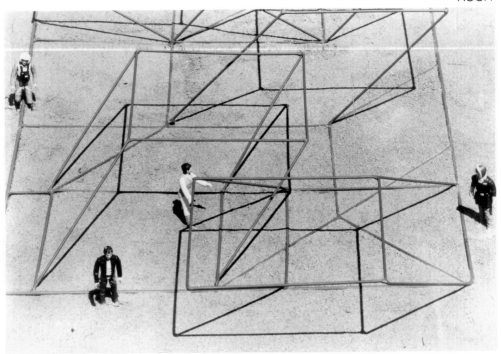

Fig. 3.8. Photographs of a hypercube sundial. As the sun moves during the day, the shadows
effect a planar rotation, coinciding with patterns on the ground on the hour.

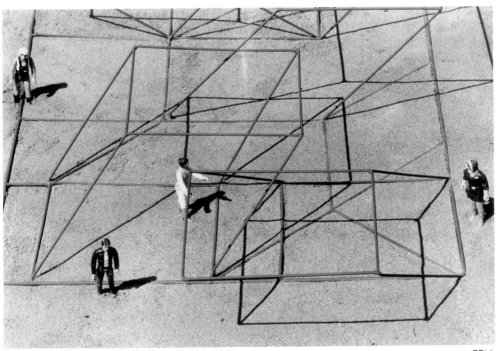

The secret of stereo is to provide each eye with a different view — a rotation — of the object. With red-and-blue stereo glasses, a red line is invisible through the red filter but looks dark through the blue filter, and a blue line is invisible through the blue filter but looks dark through the red filter. By providing a view in red from one angle, superimposed on a view in blue from a slightly different angle, each eye, when wearing the glasses, is provided with a different view that the mind collates as an experience of depth.

In my light pieces of 1983–1987 (figure 3.9, color plates 21 and 22), I found ways to use stereo and fuse it with planar rotation. Red and blue lights shine on welded-steel-rod, low-relief sculptures: a rod that blocks out the red light leaves a blue shadow, and that same rod also blocks out the blue light to leave a red shadow. The red and blue lights are placed so that the distance between the red shadow structure and the blue shadow structure is precisely right to give a stereo fusion of the images. (Where the red and blue lights shine together, the colors add to white; the wall behind the piece is pure white in color.) Thus there are two complete structures in the same place at the same time. One is made up of steel rods and parallaxes, changing its aspect as the viewer moves around it. The second structure is impervious to the viewer's movement; although it looks completely three-dimensional, it is only a product of the lights and steel structure and does not change as the viewer moves. These two structures have planes in common, and are related to one another as are the cells in hypercubes.

This technique is marvelously low-tech: light bulbs, color filters, low-relief sculpture; yet the effect is an original, gripping, and surprising presentation of the special planar rotation of four-dimensional objects. The works are large-scale; the rotations are generated by the viewer's own motion, instilling a kinesthetic experience of the four-dimensional space.

The structures are filled with transparent, colored-Plexiglas planes that filter each colored light differently so that, for example, a green plane casts a yellow and a blue shadow; yet green is again produced when these two shadows overlap. Each color is further changed when viewed through different Plexiglas planes as the viewer moves. I began to use small plaques of metal painted white so that they disappeared into the white background wall; these plaques also cast colored shadows. The viewer soon loses the distinction between a color shape that is a piece of Plexiglas, a shadow of a plaque, or a transparent filtering of a colored light, and between a colored shadow line or a line painted on a plaque,

and so on. Since all colors are equally present, the work feels like it is made up only of light, a pure crystalline structure responsive to every slight movement.

Physics has confirmed what we really knew all along: three-dimensional space is an arbitrary convention. In the future there will be many works by many artists based on a visual experience of the fourth dimension. With new works of art and new computers, the tools are already available to us for learning to see the fourth spatial dimension that is all around us and hidden from our view for only a moment. When the fourth dimension becomes part of our intuition, our understanding will soar.

Fig. 3.9. Tony Robbin, *Untitled*, 1986. Two-thirds of this image is made up of shadows that do not parallax as do the welded steel rods. Even when the shadows are made three-dimensional by wearing stereo glasses, the shadows (now more volumetric than the steel) still do not parallax.

4.

Patterns in the Ether

In *The Psychology of Consciousness*, Robert Ornstein discusses investigations done with people whose left brain and right brain have been surgically separated in a radical treatment for severe epilepsy. "In day-to-day living, these 'split-brain' people exhibit almost no abnormality, which is somewhat surprising in view of the radical surgery"[1] (i.e., the cutting of the corpus callosum, by which the two hemispheres of the brain communicate). It is well known that the right hand is controlled in right-handed people by the left brain while the left hand is controlled by the right brain. These split-brain subjects could clearly write words with their right hand but not copy the simplest of geometric figures, such as a Red Cross–type cross. With their left hands, however, these people could reproduce even a complicated three-dimensional figure, such as a house, even though they had no training in drawing, but they could not block-print even a simple word like "Sunday." The two half-brains seem to have completely different abilities and functions.

> In (one) experiment, the word *heart* was flashed before the patient, with the *he-* to the left of the eyes' fixation point, and *-art* to the right. Normally if any person were asked to report this experience, he or she would report having seen *heart*. But the split-brain patients responded differently, depending on which hemisphere was responding. When the patient was asked to name the word just presented, he or she replied, "art," since this was the portion projected to the left hemisphere, which was answering the question. When, however, the patient was shown two cards — one with the word *he*, the other with the word *art* — and asked to point with the left hand to the word he or she had seen, the left hand pointed to *he*. The simultaneous experience of each hemisphere seemed unique and independent of each other in these patients. The verbal hemisphere gave one answer, the nonverbal hemisphere another.
>
> In another experiment in Sperry's lab, the split-brain patients were shown faces that were divided in such a way that the left hemisphere would "see" only half a face, the right another. When these patients were asked to point to the face they had seen (with either hand), they pointed to the one shown to the right hemisphere. When asked to verbally choose the face, they chose the face shown to the left hemisphere.[2]

74

Ornstein concludes that the right brain is the site of the "unconscious," in that the unconscious is nonverbal, whereas consciousness (meaning self-consciousness) is always verbal. This unconscious right brain deals in gestalts rather than details, processes information in parallel, not in sequence, and as a result has a totally different notion of time. Ornstein further concludes that meditation is nothing more than the exercise of the right brain, and it appears mystical only because culture almost exclusively nurtures the verbal, sequential left brain. Finally, because patterns may have multiple levels of organization and may be seen as belonging to different gestalts at the same time, they are perceived by the right brain and as such are special entities in culture that are often used as tools for meditation.

For me, Ornstein's unusual analysis solves two great mysteries. The first is how the unconscious can be creative. If the unconscious is formed in infancy or is inherited from ancient archetypes, how could it write a Mozart symphony or discover the vaccine for polio? I am certain from my experience and reading that unconscious processes are involved in creativity. But the *source* of creativity must lie outside this traditional unconscious or we would all be creating the same things over and over. Some people believe that is true of art; for example, that all novels are re-creations of the Oedipal complex or some such universal infantile crisis. As shown earlier, artists do create new thoughts and emotions, expanding awareness and adding to the repertoire of experience. If there exist traces of the Oedipal complex in our hypothetical novel, then these traces are not the interesting or creative parts of the novel, but the uncreative ball and chain that should be considered impurities in the work. Besides, there is no disagreement about there being progress in scientific and mathematical creativity. To perpetuate the idea of the traditional unconscious being the source of artistic creativity requires the separation of artistic and scientific creativity into two quite different categories, a false separation. On the other hand, if the unconscious is primarily a second brain, designed to function differently than the verbal brain, and it is, in fact, powerfully designed to find organization and structure by lateral, non–time-sequenced pattern matching, then it is understandable how "unconscious creativity" is not a contradiction in terms.

More to the point, Ornstein's analysis solves the mystery of why patterns are universal. All peoples, all over the globe and at all times, make patterns. Patterns are more ubiquitous than the human face or form. If primitive language, number symbols, and toolmaking must now be ascribed to primates, as

some research suggests, and intraspecies warfare also exists in the animal kingdom, then the traditional definition of humankind is in error and pattern making is quite possibly the necessary and sufficient definition of humanity: humans are the ones who make patterns with the action of their right brains. Perhaps pattern making is encouraged by weaving on the loom, as the Pattern Painting critic John Perreault states, but patterns are also seen on tools from 30,000 B.C. No one knows exactly what these mean — they might be calendars or "merely" (a word often used in this connection) decorative patterns — but they predate looms. E. H. Gombrich is probably closer to the truth in his massively defended theory that patterns are universal because they are templates for the organization of experience. In Gombrich's imagery, the human mind does not act like a searchlight illuminating experience, or like a bucket into which experiences are thrown, but more like a template pulled out of a stack and used to match experience as best it can. Ornstein's analysis completes Gombrich's theory, as it shows where these templates are kept. There is nothing "mere" about patterns; they are decorative to all humans for profound reasons, associated as they are with the triumph of the human mind over the raw data of sensation.

The hearing of music is the most elegant proof that some part of our brain functions as Ornstein describes the right brain, gestalt-oriented with nonlinear time. Music takes place in linear-sequenced time, but it is not experienced that way. Notes in a melodic line are played one at a time, but we hear melody. We unconsciously (recall what that word really means) remember the note we just heard and anticipate notes that we will hear; we hear past and present at the same time. Like Feynman diagrams, which codify past and future particle physics events in a complete, static, pictorial model that can be focused both forward and backward in time, the fugues of Johann Sebastian Bach allow us to hear melodies running forward and backward in time. I once heard Bach in a small baroque church where the architecture captured the sound, further breaking up its linear sequencing, building and music joining in a single work of art. Chords of simultaneously sounded notes break apart into notes of different melodic lines running in both time directions, sometimes at different rates, and it is these melodic lines that are simultaneously grasped by the mind, not the chords. A brain equipped to hear music when presented with a series of notes, to reach beyond time ordering to grasp whole patterns, must be not only powerful but of a special design as well.

76

Spatial-complexity paintings such as Persian miniatures are pictorial equivalents of such experiences. Perhaps on initial viewing each space in the painting is viewed separately, one at a time in linear sequence, as the story is told. But we begin to remember and anticipate, experience from the right brain, see everything at once, and feel that we are in more than one place at the same time. This is the type of work our right brain wants, needs, and will attempt to do.

The first step in the acceptance of a new space is to acquire an understanding of the fundamental element of the new spatial pattern. In three dimensions, this is the cube, and in four dimensions, it is the hypercube. But ultimately the pattern of these new elements must be understood and integrated into consciousness for the space to be useful. No matter how well a cube is understood, visualized, or generalized, we do not have the ability to see three-dimensional spaces until we can imagine stacking them together. And to understand four-dimensional geometry or use four-dimensional space as the architecture to house complex and discontinuous experience, it is necessary to be able to see hypercubes stacked together.

Cubes are tessellated, or stacked, when every face of every cube is a face in precisely two cubes, thus filling all of the three-dimensional space just once. Hypercubes are tessellated when each cell of each hypercube is a cell in precisely two hypercubes.

In a letter, H.S.M. Coxeter provided me with the reasoning for this tessellation method by referring first to the two-dimensional case: a tessellation of squares is obtained by shifting squares above and below, to the left and to the right of a central square. In three dimensions, a tessellation of cubes is partially obtained by shifting cubes to the left, right, top, and bottom of a central cube. And the process is completed by applying the same operation (plus and minus one) to the third, or z, coordinate, creating two more objects that complete the three-dimensional tessellation. For four dimensions, we cover all the locations of the three-dimensional tessellation, and also place a hypercube up one place, down one place along the w coordinate axis. And so on for n dimensions (figures 4.1, 3D insert).

Hypers* is an original program from 1985–86 of eight hypercubes nested around a central hypercube, such that each cell of the central hypercube is a

*Plural of Hyper, also on the disk that is available with this book.

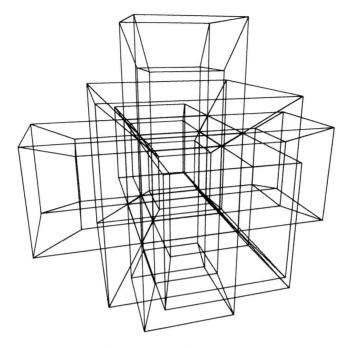

Fig. 4.1. Nine tessellated hypercubes.

Fig. 4.2. Tire tracks in the snow. This is a periodic pattern, which will exactly repeat
as long as the snow is good and there is gas in the car.

cell in just one other hypercube. The program shows a space turning in upon itself, like a doughnut shape rolling from the outer rim into the inner rim. The inner rim — the farthest cell of the farthest hypercube — expands to encompass the whole tessellation, then shrinks again. As this happens, a cross shape appears and disappears. The figure also seems to sag and shift at times, halfway through a 720-degree rotation. Although it is hard to remember that this is not a rubbery three-dimensional object but a rigid, rotating one, eventually one can learn to see the same rotations here as in the single hypercube and begin to feel that the whole space is behaving this way.

Thomas Banchoff and Charles Strauss's film *The Hypercube, Projections and Slicings* has been widely circulated for fifteen years, and has helped many to see this four-dimensional figure. Other hypercube programs have been published and distributed. The computer graphics of the hypercube is now part of the lore of both the computer graphics and the mathematics world; students at every level who are interested in expanding their powers of visualization can find access to these images. But the issue of what the fourth dimension looks like is nowhere near closed, because so little has been done with tessellations of hypercubes. The visualization of a hypercubic space follows from, but is not completely encompassed by, a visualization of a hypercube.

The big news in patterns, however, is that there exists a wholly different class of patterns — quasicrystals. Two-dimensional quasicrystals, often called Penrose tessellations after Roger Penrose, who discovered them in the mid-seventies, are made up of only two shapes or "tiles" — a fat and a skinny rhombus. Three-dimensional quasicrystals — which are made up of a fat and a skinny block — are only ten years old. What is new about quasicrystals, what has escaped thirty thousand years of previous pattern making, is that they are nonrepeating patterns.

Imagine a car's tire track in the snow. Perhaps it is a few rows of "hearts" all nested and interlocking (figure 4.2). If the snow was fresh and there was gas in the car, one could make a 500-mile track of millions of little hearts. Three hundred miles down the track one would find exactly the same sequence as in the beginning; 492 miles down the track the same sequence, because the entire track is made by the same wheel going around again and again. This is the very essence of what we mean by patterns: one or just a very few elements repeated in a regular way. Either the pattern repeats in a regular way or there is randomness. No doubt the eye and right brain work together in an especially

efficient way to precisely check and confirm these regular intervals. True, one could imagine a completely random tiling: a crazy quilt of irregular shapes with no regular intervals, adding up to no line-of-sight structures. But that crazy quilt is not a pattern; it is not captivating or satisfying and is only charming as a frustration of our natural inclination to see regular patterns.

A nonrepeating pattern, then, is an apparent paradox. The perfect stacking of just two quasicrystal elements over and over again looks and feels like a pattern. Recognizable parts of a quasicrystal do repeat, but not in a regular way. In the example shown, little rosettes can be discovered, though at odd intervals. It is even possible, when given the position of some elements, to predict the location of others, but as with the digits of an irrational number, we cannot find the regular repeat of sequence that we are so conditioned to seeing. Although we can locate many line-of-sight concurrences, and even rotations leave the pattern essentially unchanged, in that unit cells are still oriented in one or another of just a few directions, the patterns are not exactly the same after rotation — only essentially the same. Quasicrystals frustrate our common pattern-recognition systems, but we intuit that there is some kind of structure and pattern really there, and this quickly becomes endlessly fascinating. As a geometry of flux, rich ambiguity, and subtle order, quasicrystals seem elegantly to express our modern experience of space (figure 4.3).

At first Penrose tessellations were thought to be almost random. The patterns were assembled by trial and error according to matching rules, placing edges together mark to mark. This method is a local one, and even though matches are permitted in one area, there is no guarantee that this partial pattern will not run into a contradiction farther on where no tiles can be placed according to the rules. The pattern maker has to back up, make an alternate choice permitted by the rules, and try again to get beyond the area of contradiction. No predictions can be made about the position or orientation of units far from the area being worked.*

*However, a "decoration" of the tiles is possible that turns any partial Penrose pattern into one with many more smaller units. As mathematicians use the term, *decoration* means the marking of the tiles before they are assembled. All the fat tiles are marked identically; all the thin tiles are also all marked to match each other. When assembled, these markings depict small fat and thin units. These units can be "inflated" in size; they can also be decorated; and this process can repeat itself indefinitely. In this way, inferences can be drawn about infinite tessellations. Inflation and deflation capabilities also link these tilings with the new fractal geometry, in that they are self-similar at any scale.

I HAVE HEARD ROGER PENROSE lecture twice in intimate settings, and both times he spoke with a trembling voice. It was surprising, given who he is. A professor at Oxford, in demand for lectures all over the world, famous in the entire scientific community, considered by many to be Einstein's most likely heir; there is no obvious reason why Penrose's voice should quiver in sadness, or why he should project an image of power-lessness and fear. This rather extended humility struck me all the more because there was nothing tentative about the *content* of his lectures — Roger Penrose was defining existence.

This puzzle of a man might be solved by considering his work. Relativity physicists often talk about God; not because they are religious, but because there seems no other way to describe the feeling of seeing into the fundamental order of the universe as a whole. Changing the basic assumptions about reality itself is psychologically threatening no matter who you are. Prometheus stole fire from the gods and got himself into some serious difficulty. It is only prudent to beware, and only the brave can progress.

Penrose is the bravest thinker I know about. By comparison, everyone else seems to be futzing around with minor details at the edges of The Problem. Others talk about the end of chemistry or physics: the last elementary particle will soon be discovered, and all the fundamental forces of physics will be duly cataloged and measured. Such sentiments must sound silly to Penrose. "We are not close, even in physics," he says. Particles have a way of knowing that we cannot imagine. We also have a way of knowing that mathematics cannot emulate. These two ways of knowing are interconnected — perhaps in a space of which we are unaware. Of course he is awestruck — only characters in fairy tales are confident of their knowledge. Even though it makes him nervous, Penrose prefers the excitement, the dream of true heaven, to the comfort of ignorance.

Largely unbeknown to the mathematical community, architects were working on a three-dimensional version of Penrose tessellation while this preliminary work with the mathematics of two-dimensional patterns was being done. In the early seventies, Steve Baer (see box on pages 96–97) discovered that dodeca-hedra could be used as nodes for structures. Nodes and rods may be assembled to make rhomboid blocks, which in turn may be assembled into larger structures. Baer recognized that these structures had many special properties that we have come to call quasicrystal (figure 4.4).

Later in that decade, the Japanese architect-geometer Koji Miyazaki worked with the known subassemblies of the fat and skinny blocks, the golden zonohedra (figure 4.5). They are: the fat rhombohedron; the rhombic dodecahedron, made up of two fat and two thin rhombohedra; the rhombic icosahedron, made up of five fat and five thin rhombohedra; and the rhombic triacontahedron, made up of ten fat and ten thin rhombohedra. (These medium-sized subassemblies of the units of quasicrystals are called "golden" because, like the pentagon, the dodecahedron, and the two-dimensional Penrose tessellations, they have the golden ratio built deep into their mathematical structure.) Miyazaki found that the golden zonohedra can be assembled to make three-dimensional patterns; for this insight, he should be credited with the discovery of quasicrystal tessellation.

In 1980 the Dutch mathematician Nicholas de Bruijn made the most important discovery of all about quasicrystals. De Bruijn's genius was to see that Penrose tessellations could be generated by a global, foolproof method. He had been studying systems of equations — little mathematical machines, really — that generate long lines of 0s and 1s, when he realized that these lines were really one-dimensional quasicrystals — nonrepeating patterns with a hidden structure. He then connected the centers of the tiles in a Penrose tessellation,

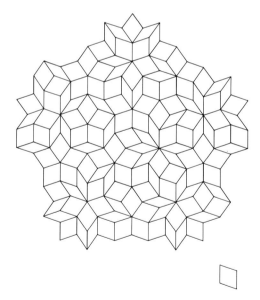

Fig. 4.3. This two-dimensional quasicrystal was generated on my computer by the de Bruijn dual method.

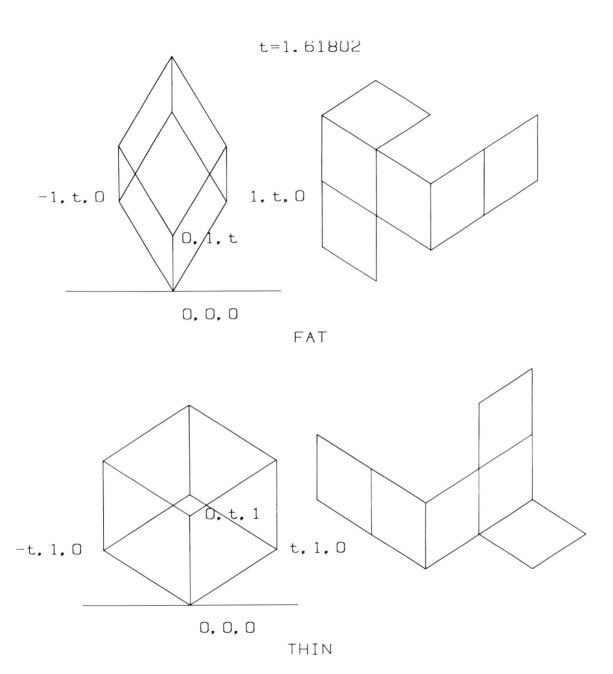

t=1.61802

−1, t, 0

1, t, 0

0, 1, t

0, 0, 0

FAT

0, t, 1

−t, 1, 0

t, 1, 0

0, 0, 0

THIN

Fig. 4.4. The fat and skinny unit cells of quasicrystal tessellations. If you are so inclined, photocopy this page, and cut out and fold up the unfolded cells.

and discovered that the pattern of the centers, called the *dual,* could also be generated by the same system that generated the 0s and the 1s. All that remained to complete the pattern was to build a unit cell, or tile, around each intersection in the underlying dual grid. To the amazement of all, what had been considered to be basically random patterns were shown to have a subtle, hidden structure after all. The screw had turned once more: these nonrepeating patterns were generated by a repeating system. Having such a system means that quasicrystals can be generated on a computer; a computer algorithm is just a restatement of the mathematical system in computer language. This was done by physicist Paul Steinhardt and his collaborators (figure 4.6).

The computerized dual method proved to be powerful. It can generate an infinite number of Penrose tessellations, as well as patterns that at first look for all the world like Penrose tessellations and are not, and three-dimensional quasicrystals. In every case it shows us why the mix of predictability and unpredictability is a result of the underlying dual. Sequences of units along an axis can be predicted by the number machine once the start-up position of the machine is established. The method shows why there is long-range orientation and shows why and where the golden zonohedra float in a quasicrystal. Some people feel that only these zonohedra, and not their constituent fat and skinny blocks, are the full analogue of the two-dimensional Penrose tessellation; only these zonohedra can be "decorated," and thus inflated and deflated. There is

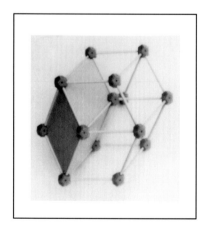 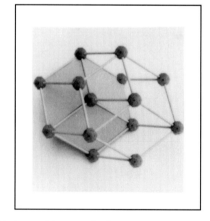

Fig. 4.5. Miyazaki's nodes and rods assemble into golden zonohedra, which can then be fitted together to form quasicrystal packings.

84

no known method for decorating the fat and skinny blocks themselves, which otherwise fulfill all requirements of quasicrystal unit cells. Thus the feature of the dual method that articulates the zonohedra shows the fullness of the hidden order.

Squares fit nicely around squares, as do triangles around triangles and hexagons around hexagons. But pentagons so arranged leave gaps. Dodecahedra and icosahedra, the three-dimensional analogues of pentagons, also leave gaps, unlike cubes, which do not. For this reason, it was thought that no lattice could be built, either with plastic blocks or with atoms, that would have the fivefold symmetry of pentagons. But Penrose patterns and quasicrystals do have fivefold symmetry — unit cells, and their underlying duals, line up according to axes that come straight out of a pentagon. It is both their nonperiodicity and their fivefold symmetry that make quasicrystals especially exciting prospects to solid-state physicists.

Quite by accident, D. Shectman and his collaborators discovered in a rapidly cooled sample of an aluminum-manganese alloy the disallowed fivefold (pentagonal) symmetry, and Steinhardt suggested that they may be serendipitous quasicrystals. Initially there was debate among scientists as to whether these small early samples might have only the illusion of fivefold symmetry or whether they had only a few atoms in such an arrangement and could not be expanded into whole crystal lattices. Now large, flawless samples have been made in

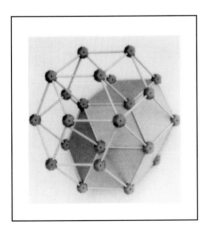
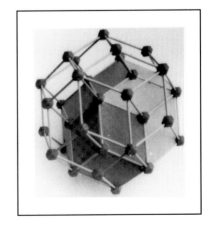

Fig. 4.6. Steinhardt's computer-generated image of a quasicrystal packing.

several physics labs, and it is clear that they are truly quasicrystals. Research can now focus on their electrical and chemical properties, possibly with quite startling results.

There is still a major philosophical debate about what it means that these quasicrystals can be formed. If Steinhardt is correct that he has found a new set of matching rules — step-by-step local operations — that is foolproof, then it is possible to imagine some physical implementation of these rules. Quasicrystals would form when atoms connect to one another according to the local forces described by these rules. If Penrose is right that no such foolproof set of matching rules exists, then perfect large-scale quasicrystals can only form by reference to a global and algorithmic system. But what do little atoms know about the big picture? For Penrose that is precisely the point: they *do know* about the big picture, just as quantum theory suggests particles "know" about other places and other times. Thus quasicrystals are macroscopic quantum effects and as such are a model of everything, as everything is built up from quantum effects.

In *The Emperor's New Mind,* Penrose makes a breathtaking leap into speculation. Computers, as they are currently structured, are incapable of dealing with the real world; like all of mathematics, they suffer from being only an elaborate self-referential, linear tautology, where all results are prefigured in the original assumption. Yet we humans have a way of knowing superior to that elaborate tautology; for one thing, we can know the computer's limitations. Penrose posits that our knowledge is enriched by quantum processes in our minds, for, as we have seen, quanta have a way of interacting — a way of knowing about each other — that is not linear. Assuming there are no foolproof step-by-step matching rules, quasicrystals in nature partake of that quantum nonlinear way of interacting, and so are the model of the patterns of neurons in the brain. Such a neural network could also be applied to electrical components to make a computer that could really learn and think. Penrose is the bravest thinker I know; I believe this speculation is profound, and that it integrates so many disparate ideas that it must be true. Nevertheless, on the basis of my experience, I think Steinhardt is right that a foolproof, local, step-by-step system exists for making quasicrystals; that it is therefore not necessary to see them as macro quantum effects, and must to some extent undermine Penrose's speculation (figure 4.7).

With Steinhardt's help and using de Bruijn's powerful dual method, I have

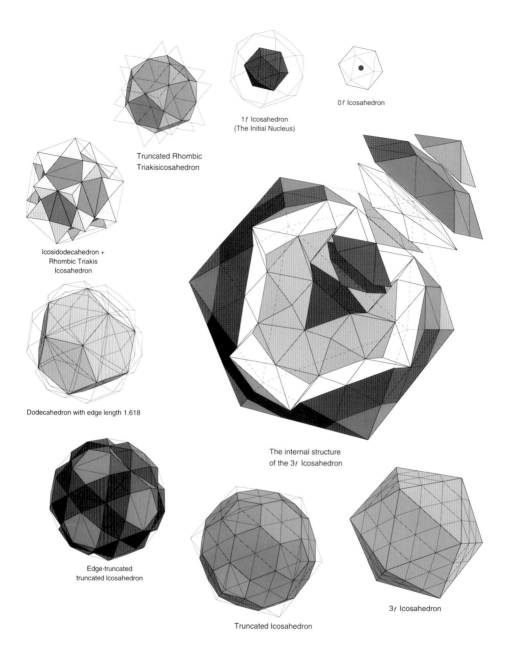

Truncated Rhombic
Triakisicosahedron

1*f* Icosahedron
(The Initial Nucleus)

0*f* Icosahedron

Icosidodecahedron +
Rhombic Triakis
Icosahedron

Dodecahedron with edge length 1.618

The internal structure
of the 3*f* Icosahedron

Edge-truncated
truncated Icosahedron

Truncated Icosahedron

3*f* Icosahedron

Fig. 4.7. Artist and founder of the Japanese Synergetics Institute, Yasushi
Kajikawa found this alternate set of unit cells, which tessellate
aperiodically according to foolproof, step-by-step local rules to make nested icosahedra
and dodecahedra with 5-3-2 symmetry. The set of unit cells is large, however, consisting
of five tetrahedral cells and five octahedral cells, the size of which must be increased
with each concentric shell.

written computer programs that generate and shape quasicrystals, demonstrating the visual behavior of these structures as seen from different angles.*
Sometimes they seem to have fivefold symmetry and are pentagons and star pentagons. Other times they seem to have threefold symmetry, and appear to be made up of triangles, hexagons, and 60-degree parallelograms. Still other rotations reveal them to have the twofold symmetry of squares and diamonds. It is thrilling to see these structures transmute before your eyes, in real time, becoming one thing and then another, dissolving cells at one place and recreating them elsewhere, becoming one moment a dense thicket and the next a transparent lacework — and all the while to know that the structure is not really changing, that only a rotation of a fixed, rigid structure is being observed. It is as though three different structures were hidden in one.

The experience of watching these structures transmute to one another supports my idea of applying this geometry to architecture and environmental sculpture. I am convinced that even if quasicrystals do not turn out to be important to physics they will be a major contribution to architecture. Experimenters know that they have a sample of quasicrystal material when they shoot X rays through it and obtain a pentagonal scatter pattern, and then turn the sample to obtain a scatter pattern of isometric triangles and hexagons, and turn it again to obtain patterns with right angles. Knowing that photons and X rays are the same thing, I realized that quasicrystal architectural structures would cast shadow patterns that transmogrify as the sun passes overhead.

Rays of light from the sun are parallel to each other, and cause shadows to be cast in isometric projection like two-dimensional projections of three-dimensional quasicrystals. Thus it is possible to build structures that behave visually like the computer program I have written. For example, consider Buckminster Fuller's geodesic dome in Montreal. This structure casts a shadow that is an intricate triangular net; as the sun moves across the sky the triangular-net shadow shifts across the floor. If the dome were made up of quasicrystal elements, the shadows would be seen not so much as shifting but as transforming from a pattern of triangles to one of squares, to one of a two-dimensional Penrose tessellation, to one of pentagons, and back again to one of triangles and hexagons (figures 4.8 4.9, 4.10). The same effect could be obtained with

*On the disk that is available with this book is the program Quasi, which allows you to see this for yourself, though these are simpler quasicrystal objects not generated by the dual method.

Fig. 4.8. Four views of a quasicrystal dome, Tony Robbin, 1991: morning, noon, and afternoon on top, and an elevation of a dome with seven hundred nodes below. The computer first generated a giant cluster of eight thousand cells, then scooped out this dome, rotated the dome, and finally plotted out the drawings.

Fig. 4.9. Tony Robbin, *Quasicrystal Spaceframe*, 1989, brass model.
The shadow at noon is a Penrose tessellation.

a quasicrystal space frame (a flat slab), a barrel vault, or even a spherical cluster seen from many angles if, for example, it were hanging in an atrium space where viewers could stand underneath as well as on balconies. Indeed any quasicrystal structure in any arbitrary shape has these visual properties. Moreover, these visual effects could also be obtained by the motion of the viewer as she walks around the outside of a dome or underneath a quasicrystal ceiling or even by just turning her head. Quasicrystals are exquisitely and magically responsive to both changes in light and to the viewer's movement. Buildings could become effervescent and seemingly alive.

Magic is only a technology that we do not understand. At the turn of the century a great magician performed an amazing feat. A small box was placed on a heavy table covered by a cloth. The smallest of boys in the audience could pick up this small box, but after some magical incantations not even the strongest of men could lift it. Since today we are all familiar with electromagnetism, it is easy for us to comprehend that the small metal box could be alternatively heavy and light if the current to a large electric magnet hidden in the table was switched on and off, but to people of the time the effects were astounding.

Like other large structures built with a new and still obscure technology, the effects of quasicrystal architecture would seem as miraculous as Saint Chapelle, the Eiffel Tower, or the Grand Coulee Dam must have seemed to their first viewers, and still are for us to some extent. To build a crystal cage for the capture of a deity, to build a tower so much higher than any other structure, to fill in a mountain so that the vast American landscape can be pressed into the service of human beings, these are magical feats of mathematics and engineer-

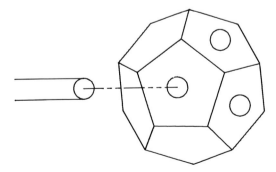

Fig. 4.10. Every node of every quasicrystal structure is a dodecahedron, and within any single quasicrystal structure (no matter how big) all the nodes are in the same orientation.

ing; they also tell us something profound about the values of the people who built them. In the case of the quasicrystal, even on a much smaller scale, we could be allowed the satisfying experience of seeing in complexity and apparent confusion a pattern, a symmetry, that is elusive, subtle, flexible yet powerful.

All quasicrystal structures can be made with plates that could be made out of metal, plywood, or even glass (figures 4.11, 4.12). Since all the faces in a quasicrystal structure are identical, all the plates would be the same basic shape. To assemble these plates into fat and skinny cells, they must have different bevels, equaling one-half of the dihedral angles of the various faces of the various blocks. I have discovered, however, that only two sets of bevels are needed (which correspond with Penrose's matching rules). The result is that all the plates can be made identically, then divided into only two groups for beveling. Six plates from each group can be assembled only one way, into either the fat or thin cell from which all quasicrystals are constructed.

I am convinced that quasicrystals have novel structural properties, and that buildings based on quasicrystals would also be interesting for their engineering, though I am still searching for a practical way to exploit this novel engineering. Because they are nonrepeating patterns, quasicrystals are structurally different from the hundred-year-old geometry of the Eiffel brothers, still called modern and still, for many, the paradigm. In quasicrystals, forces are not translated directly as with other structures; rather, loads are instantly diffused in all directions. Yet these resilient and flexible structures can be stiffened with the use of tensile membranes, new materials, or open plates.

It has been well known from before the time of the Eiffel Tower that stiff truss structures can be made by assembling triangles. It is neither difficult nor novel to introduce rigidity into these structures; what is hard to accomplish and frequently necessary is to introduce flexibility without losing strength. Steinhardt originally thought of quasicrystals as a model for an idealized fluid, and that pressing on one part of a quasicrystal structure would cause attempts to dislocate many other parts of the structure in directions greatly different from the original force. This is like pressing on a balloon filled with water — the force is not translated through the balloon to come out of the structure on the opposite side, basically unaltered, as would be the case in a truss. Rather, the force is diffused in all directions and absorbed by the structure as a whole. The structure, like the water-filled balloon, is only as weak as the stress skin resists tearing (figure 4.13).

92

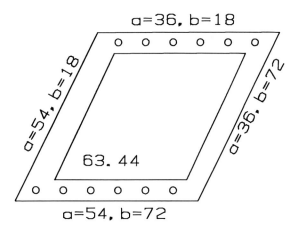

a=36, b=18

a=54, b=18

a=36, b=72

63. 44

a=54, b=72

Fig. 4.11. The plates for quasicrystal structures. Six plates of type *A* make the fat cell and six plates of type *B* make the skinny cell. The numbers refer to the degrees of bevel of the edge.

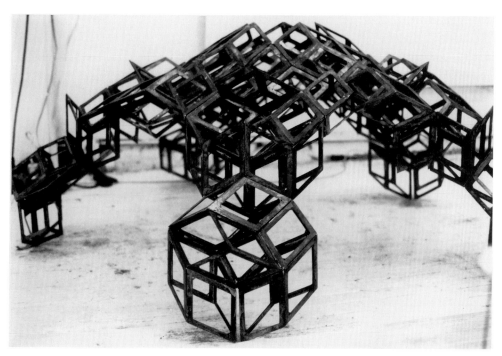

Fig. 4.12. Tony Robbin, *Quasicrystal Dome*, 1990, zinc model. This plate model is based on the dome shown in figure 4.8.

93

When maximum flexibility is required, in an earthquake-prone area, for example, even large-scale quasicrystal structures could be built using new spring concrete, which can flex. When built with rods and nodes, quasicrystal structures can be thought of as complicated three-dimensional flexors that "spring" in many directions at once. The use of open plates maintains all the visual properties of quasicrystal architecture. Further, plates have many practical advantages: any three plates meeting at a corner form a rigid unit; the edges of the plates carry the load, making the nodes structurally unimportant; as we have seen, only two plates make every quasicrystal structure, allowing an ease of fabrication; and units can be prefabricated on the ground and hoisted into place.

Fig. 4.13. This sphere has a quasicrystal interior of lightweight metal and is covered by stretched canvas. It can support a full-grown artist.

For anyone familiar with the quirky behavior of four-dimensional geometry, quasicrystals present an eerie déjà vu. Although they are three-dimensional objects, they have associations with the fourfield: more than one structure in the same place at the same time, each revealed by rotation. In fact, one of de Bruijn's methods for generating quasicrystals involves taking hypercubic lattices from six dimensions, turning them, filtering them, and projecting the remainder into three dimensions. Theoretically, this projection technique could be extended to eight dimensions to obtain a four-dimensional quasicrystal where the unit cells would be skewed hypercubes, which Neil Sloane and Viet Elsner have done. But not everyone is convinced that escalations to higher

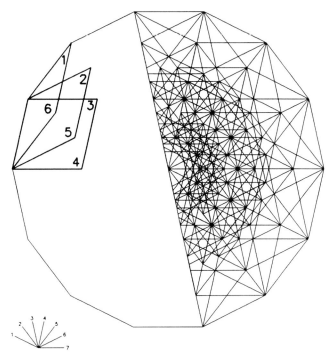

Fig. 4.14. Haresh Lalvani's central projection of a seven-dimensional cube
gives a figure with fourteen sides. Multiples of the angle from the
center to two adjacent vertices (25.714 degrees) make up unit tiles. The multiples are in the
cuplets 1 and 6, 2 and 5, and 3 and 4 (all of which add up to 7), meaning that one unit tile has one
angle equal to the central angle (25.714 degrees) and the other angle equal to six times that
central angle (154.285 degrees), and so on. These cuplets tell us that the two-dimensional
quasicrystal tessellation based on a projection of the seven-dimensional cube has three
unit tiles; this relationship between unit cells and multiples of the central angle of the projection
is true for all dimensions.

STEVE BAER dropped out. In the sixties, dropping out of college was not the same as flunking out due to stupidity, or leaving school for financial reasons, or simply losing interest in academic studies. Dropping out was a political statement: the establishment would no longer be permitted to define the objectives and values of the dropee. With the residents of Drop City, he built polyhedral domes in the same spirit that Steven Jobs built his first computer: cheap, fast, and personal. Computers, housing — such things were too important to be the exclusive province of "Them." Discover and employ the secrets of geometry for yourself, to empower the people.

For Baer, rebellion meant the spurning of the right angle. In 1967, when laying out a ninety-sided sphere made of "chopped car and van tops from the junkyard," Baer noticed that the nodes used to construct such a figure could be icosahedra. He knew that the icosahedron and the dodecahedron were duals; chopping off the tips of an icosahedron makes a dodecahedron, while building pyramids on the faces of a dodecahedron turns it into an icosahedron. Thus icosahedral and dodecahedral nodes were geometrically interchangeable. Two years later he was building playground climbers using dodecahedral joints.

Such structures captivated Baer and his collaborators because they were so different. Not only were they different from what "They" were doing, they were different from what nature was doing. Crystalline structures in salt and alum are in the form of the cube and the octahedron respectively, with an atom at each vertex of geometric shape and the shapes stuck together in a three-dimensional grid. Builders since the time of Eiffel have loved the tetrahedron and pyramid, as does nature in forming crystals of sodium bromate, for example. But nature does not make lattice structures using the dodecahedron because it cannot; the units would not fit together. (Only now do we know, with the discovery of quasicrystals, that such structures can be made in physics labs and so might also exist in the wild, perhaps near some volcano.) It must have seemed to Baer that he had double pleasure; once freed of "Their" agenda, he could not only make things never seen before but he could stick his thumb in Uncle Sam's eye at the same time.

If neither Nature nor Uncle Sam, at least God and Plato were on Baer's side. At every turning, the golden section is there. Sometimes called the divine proportion, the golden section is a division of a line such that the larger portion is to the whole line as the smaller is to the larger portion. The ratio is an irrational number called *Tau*, equal to $\frac{1+\sqrt{5}}{2}$ or 1.6180. This

dimensions are so straightforward. My own efforts at using the dual method in four dimensions are inconclusive; but nevertheless, there is something about quasicrystals that alludes to higher-dimensional space.

An architect, Haresh Lalvani, has found one interesting connection. The central projection of a higher-dimensional cube is a regular polygon. The central angle of this polygon is the angle from the center to two adjacent corners. Multiples of the central angle form the acute angles of the rhombic shapes of the unit cells for that dimension of quasicrystal. Another way of saying this is that the vertices of the higher-dimensional cube — in central projection — give us the corners of all different kinds of fat and skinny blocks that make up the respective quasicrystal. Such a discovery, along with de Bruijn's projection method, support the hunch that there is a deep connection between tessellations of hypercubes and quasicrystals, and that the study of the projection of four-dimensional space is far from over (figure 4.14).

To adopt the Gombrich-Ornstein thesis literally is to recognize the precise way in which new patterns define and support consciousness. The fourfield and quasicrystals are new patterns; they are templates for experience not yet in the right brain's storage racks, and are thus a challenge. Yet these new patterns are also a tremendous opportunity. Once integrated into our habits of thinking, they will turn up in the most unexpected places. Buildings with magical visual properties are just the beginning.

ratio crops up everywhere in quasicrystals and in Baer structures, and reinforces the notion that there is some deep mathematical structure hidden inside. Baer writes with passion about that deep structure; it still motivates him.

But these days, things are different. Baer runs two companies; one builds solar panels and the other designs and markets geometric toys. Baer complains about the government, of course, but more from the point of view of a businessman harassed by bureaucracy. Baer did not invent quasicrystals as he thinks; rightly, he is not cited in mathematical papers. However, off the books and out of sight, he began putting the pieces together, and anticipated some of the structures of quasicrystals. Hey, he has got the patent — government patent #3,722,153 — to prove it.

5.

Curvature:
Lobofour and Nonclid

To more fully imitate the space of nature, it is necessary to use non-Euclidean geometry, because it can accommodate forces that distort measurement. My understanding of this application of curvature begins with a drawing from Hans Reichenbach's *The Philosophy of Space and Time*, published in 1927 (figure 5.1).

Reichenbach's point is that Flatlanders living on the top line could only know they were living on a curved surface if they could compare their measurements with the corresponding measurements on the bottom line; the distance from A' to B' is not equal to the distance from A to B, and by referring to the flat lower line they could see that they "should" be equal. Conversely, Flatlanders

Fig. 5.1. Hans Reichenbach's example of curvature. If we are on the bottom, flat universe and become aware of something weird that has been affecting our measurements, then we are really living on the top, curved universe.

living on the bottom line, could just as easily imagine that they were living on a curved universe if they also noticed a force that shrank their measuring rods in just such a way as to make their measurements conform to the observations of the Flatlanders living on the top line. In other words, if Flatlanders on the bottom were to measure the interval between *A* and *B* and find it to be unequal to the interval between *P* and *Q*, and they suspected that their measuring rods had been shortened in the *A*, *B* region by some physical force like heat or gravity, then they could fairly say that, discounting the corrupting physical forces, they were living on a surface just like the top line.

Reichenbach states that we are like the Flatlanders living on the lower line. Our universe might at first look flat until we notice that some measurements are distorted by physical forces. By referring these jumbled measurements to a curved universe, our model of space becomes more consistent, with more regular intervals. Moreover, Reichenbach believes it is possible to learn to see the curved universe, and prefer its conceptual clarity to the chaotic collection of shrinking rules that result if we perpetuate the habit of modeling the universe as flat. The two models of space are truly equivalent, and it is our choice which model we wish to see — either a complicated flat space with not-so-well-defined forces that distort measurements, or a regular, well-defined space that takes a little getting used to because it is curved.*

Of course, Reichenbach's breathtakingly simple diagram refers to the complex general theory of relativity, which incorporates gravitational forces that can change measurement, and which abandons comparisons to a God's-eye view. While the space of special relativity holds out the possibility of an ultimate frame of reference, albeit a complicated one, where events are plotted on a four-dimensional grid so that all vagaries are resolved, the general theory shows us the essential equivalence of each spatial system. In discussing his famous elevator thought experiment in which physicists are unable to distinguish between being in an elevator being pulled up or being in a stationary elevator sitting in a gravitational field, Einstein states:

*Reichenbach could not know that later research would suggest that the space of the universe as a whole is close to being flat, allowing one to argue that space is "empirically" flat, not flat by convention — "epistomogically," as Reichenbach puts it. However, it is still true that, at the scale Reichenbach is considering, the scale of planets, stars, and galaxies, the convention of flat space must include a force — gravity — that shrinks measuring rods, slows clocks, and bends light rays, whereas the convention of curved space needs no additions to describe events accurately.

But for such a description we must take into account gravitation, building so to speak the "bridge" which effects a transition from one CS [coordinate system] to the other. The gravitational field exists for the outside observer; it does not for the inside observer. Accelerated motion of the elevator in the gravitational field exists for the outside observer, rest and absence of the gravitational field for the inside observer.[1]

Misner, Thorne, and Wheeler go so far as to mock the smugness with which we choose one frame of reference over another:

"Gravity is a great mystery. Drop a stone. See it fall. Hear it hit. No one understands why." What a misleading statement! Mystery about a fall? What else should a stone do except fall? To fall is normal. The abnormality is an object standing in the way of the stone. If one wishes to peruse a "mystery," do not follow the track of the falling stone. Look instead at the impact, and at what was the force that pushed the stone away from its natural "world line," i.e. its natural track through spacetime. . . . Forgo talk of acceleration! That, paradoxically, is the lesson of the circumstance that "all objects fall with the same acceleration." Whose fault were those accelerations, after all? They came from allowing a ground based observer into the act. The push of the ground under his feet was driving him away from a natural world line.[2]

The lesson of general relativity, then, is that to see space whole and pure, we must abandon the notion that our place in space is privileged (is at rest; is the one place where gravity is focused), and that means seeing space curved.

For Reichenbach, visualization of non-Euclidean geometry is based on our becoming accustomed to a new concept of congruence. Congruence is a basic axiom of Euclidean geometry — that a shape remains the same shape when moved — but congruence does not hold true in non-Euclidean geometry:

Any adjustment to congruence is a product of habit; the adjustment is made when, during the motion of the object or of the observer, the change of the picture is experienced as a change in perspective, not as a change in the shape of the objects. Whoever has successfully adjusted himself to a different congruence is able to visualize non-Euclidean structures as easily as Euclidean structures and to make inferences concerning them. . . . It is indeed possible to visualize non-Euclidean space by an adjustment of visualization to a different congruence.[3]

100

Thus, by keeping track of the changes in a shape as it moves around in a space, the non-Euclidean character of that space can be seen.

Another avenue for the understanding and visualization of non-Euclidean space is to consider the value of pi. In Euclidean geometry the ratio of the circumference of a circle divided by its diameter is denoted by the Greek letter pi and is about 3.14 ($\pi = \frac{C}{D}$). In a positively curved space measurements are such that the *diameter* is relatively larger, so that the circumference divided by the larger diameter gives a number, a value of pi as it were, that is smaller than 3.14. On the other hand, a *circumference* in a negatively curved space is larger, so that the ratio of circumference to diameter is greater than the Euclidean value of pi.

One type of two-dimensional positive curvature is the surface of a sphere, like the Earth. The circumference is the equator and the diameter is the distance from the North Pole to a point on the equator. This "diameter" is larger than the straight-line distance from the North Pole through the Earth to that point on the equator, but only the surface of the Earth counts as space, and only paths on its surface are allowed. A two-dimensional, negatively curved space might be thought of as a wavy saddle shape. The distance from the center of the saddle to the rim follows a curved path, but the rim of the saddle is wavy and so its circumference is much longer than that of a simple bowl shape.

Two spaces might each look "straight" from inside, yet both look curved from the other. In other words, my space looks straight to me and his looks curved to me, but his looks straight to him and mine looks curved to him. He and I could measure circles and diameters and compute pi, and find out which one of us is curved according to Euclid. However, neither one of us has any basis to say that Euclid was right about the value of pi in any absolute sense (be sure his measurements were not made in the presence of some mysterious, distorting force), and so we are back in the same muddle as before.

Imagine a topological approach, where we pay attention to unit tiles rather than to the lengths of their edges and our only way of measuring is the counting of whole tiles (figure 5.2). In a Euclidean space a tessellation of hexagons consists of six hexagons around each hexagon; pi in Euclidean Hexagonland is equal to six. But in a negatively curved Hexagonland, there would be more than six hexagons around each hexagon, and pi would be correspondingly larger than six. M. C. Escher has done precisely that in his 1960 woodcut *Devils and Angels*. Each Angel or Devil is really a triangle, and three Angels and three

Devils make a hexagon. On each edge of the central hexagon there is a similar, though smaller, hexagon, and there is also a hexagon on each of the six vertices of the central hexagon. Thus, choosing any hexagon as a starting point, we can count twelve hexagons surrounding it. Diagraming the woodcut presents the structure clearly (figure 5.3).

I discovered this property of non-Euclidean tessellation for myself in a tessellation of eight-sided figures and four-sided figures, octagons tiled on their faces with leftover squares on the diagonals, familiar from many bathroom floors (figure 5.4). The perimeter of the most symmetrical projection of the hypercube describes an octagon, and so this tessellation is perfectly suited for four-dimensional paintings. (I rejected this pattern for *Fourfield* only because I wanted a nonrepeating pattern.) These octagons and squares were drawn with a series of rulers that became progressively shorter as they moved around the surface. I made a collection of rulers of different lengths, exchanging them as I went along, and discovered that following a shrinking rule rigorously led to a recalculation of pi. I needed more than four octagons to go around each square, and more than four octagons and four squares are needed to go around each octagon. One way to obtain the "extra" tile is to make the four-sided figures into five-sided figures, as I did for paintings like the one illustrated here (black-and-white plate 16).

Fig. 5.2.

A pattern of hexagons;
six always fit around each one.

Fig. 5.3.

A pattern of non-Euclidean hexagons;
in this case twelve fit around each one.
In non-Euclidean space each hexagon
is the same size and shape.

102

Mathematicians often model non-Euclidean tessellations inside a circle, where the edge of the circle is considered to be infinitely far away. Unit tiles get smaller and smaller as they approach the edge, as in my diagram. There is a changing congruence rule, however, that says that all the shapes are identical.* The circle model is well established, but I am not sure it is always used correctly. To be truly a non-Euclidean model, usually a negatively curved or hyperbolic model, the patterns drawn in the circle should have the redefinition-of-pi feature that I mentioned. If six hexagons fit around each hexagon, and all these hexagons are understood to be the same size and shape, then what is inside that circle is a model of the flat Euclidean plane. On the other hand, if five pentagons fit around each pentagon inside one of these circles, then it is a model of non-Euclidean space, because on the Euclidean plane five pentagons, one on each side, do not quite fit around another pentagon. That particular model is of a positively curved space: fewer unit tiles than a Flatlander expects are used to close a circumference.

*Actually, there are two different models used to model negative curvature in a circle, though these two models have been shown to be essentially the same. In the Beltrami-Klein model, straight lines remain straight though angles are distorted. In the Poincaré model, straight lines appear curved but angles are preserved. Even such schematic models as these prove useful to mathematicians in reasoning about non-Euclidean space.

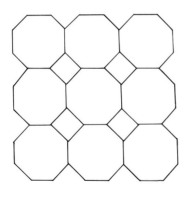

Fig. 5.4.

Pattern of octagons and squares,
a familiar pattern from the floors
of old washrooms.

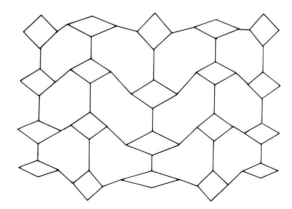

Fig. 5.5.

Grid for *Lobofour*.
Four- and eight-sided figures are tessellated.

In general, as William Thurston and Jeffrey Weeks have shown,[4] models of *positively* curved spaces develop inaccessible regions, where space stops being space even though we can point to those regions; and models of *negatively* curved space develop overlapped regions where there seems to be more space than space can hold. These tucks and darts become manifest when the non-Euclidean space is modeled in the flat space we insist on conceptualizing because we think it is easier. In both the positive and negative cases, these problems get worse when the space is colored in. Something has got to give. Either the number of sides of a shape must change; or, eventually, a whole shape must be skipped or doubled; or the coloring must be swapped so that, in the example above, colors of the octagons would have to be swapped with the colors of the squares. Adding a side to a shape or skipping a shape now and then defeats the regularity of the tessellation, and changing the coloring is equivalent to changing the number of sides of a shape; in this case, changing an eight-sided figure into a four-sided one. Problems of coloring are important because coloring defines in a consistent way which subsections of the space are juxtaposed and whether or not spaces are weirdly connected or come to blind alleys.

Collapsing metrics and their relationship to both relativity and perspective, changing values of pi, coloring non-Euclidean tessellations, and new congruence rules — all these ideas swirled in my mind and would not come to rest. These speculations began in a dream I had in the spring of 1975, after my solo exhibition at the Whitney Museum of American Art in New York and after my father died, as I began serious study of four-dimensional geometry and saw the two colors of light in my loft. My dream was related to all these events. In this dream Einstein, as a new father, came to tell me that in some sense four-dimensional structures must be curved. For several nights this dream woke me up, and kept me up, thinking and scribbling cryptic notes I now cannot understand. Eventually, I learned that, in a sense, the dream Einstein was a false prophet, because four-dimensional geometry and non-Euclidean geometry are two distinct subjects (though projected figures are something of a bridge between them).* At any rate, seven years later, I was still testing the message of that dream.

One of the main results was a piece I called *Lobofour* (1982) because it is a fourfield with the negative curvature first studied by the nineteenth-century

104

Russian mathematician Nikolai Lobachevsky (color plate 19). In *Lobofour* the map-coloring problem is solved in an original way (figure 5.5). By distorting the angles, but not the edge lengths, of the four-sided figures I could absorb the shock, as it were, of the shrinking rule and thus maintain both the non-Euclidean tessellation and a consistent map coloring. In *Lobofour*, the four-sided figures are yellow/orange alternating with orange/brown on five vertical columns. In the center, the four-sided figure at the bottom is a square (with 90-degree angles), and, rising up the column, it becomes more and more oblate. This is also true of the two columns on the far left and right. In the remaining two columns the progression is reversed. The fat four-sided figures are at the top and the thin four-sided figures are at the bottom. The magic is good only for so long; a few more courses and the four-sided figures are so flat they are lines and the tessellation is defeated. But, in the local area of the painting, there is a regular, intrinsically curved pattern.

Once this base grid was established, *Lobofour* was completed with the same approach used in *Fourfield*, except that the lengths of the steel rods shrank with the dimensions of the base grid. To some extent the legibility of the hypercube was sacrificed for the non-Euclidean distortion, and simpler parts of the hypercube had to be used. To my knowledge, this painting is the first attempt to build a model of the visual information of a four-dimensional, negatively curved field.

When I visited Thomas Banchoff in the summer of 1979, I also saw the work of his colleague Jonathan Lubin, who had computer-generated drawings of negatively curved patterns. They were made of strangely looping curved lines. His model did not have the property of having more tiles than the "right" number around each tile as a definition of curvature. It did, however, convince me that computers could be as helpful in learning to visualize two- and three-dimensional non-Euclidean geometry as in four-dimensional geometry. As soon as I had learned to program the basic hypercube, I also began working on the problem of programming a three-dimensional non-Euclidean grid, which resulted in a program I dubbed Nonclid.

*Yet, from the point of view of someone in four-dimensional space, all that is seen are the projections of four-dimensional figures to that space, and these projected figures have only the pseudo-Euclidean character discussed in chapter 3. As I have said, the importance of these not-quite-Euclidean projected figures has been largely missed, and so perhaps the dream Einstein has something to contribute after all.

Unlike programming four-dimensional cubes — where the equations had already been published by Michael Nöll, and the technique was a relatively simple extension of three-dimensional procedures — there were no models or accepted techniques for programming non-Euclidean geometry. I needed the collaboration of Herbert Tesser, a physicist turned programmer who at that time was head of the computer science department at Pratt Institute in Brooklyn, and who took me in as a refugee from the art world. Tesser took a special interest in my projects, made a place for an artist a tad long of tooth as a special student in his department, and worked so much on the non-Euclidean program that it is fair to call him its coauthor.

In the most general form of non-Euclidean geometry (invented by Carl Friedrich Gauss and Georg Friedrich Bernhard Reimann), distances between points in space are given by:

$$\text{distance}^2 = Ax^2 + By^2 + Cz^2$$

This formula follows the familiar Pythagorean formula for distance except that here the terms A, B, C are coefficients of curvature at those locations and must be used in the calculation. That is to say, each point in space not only has a

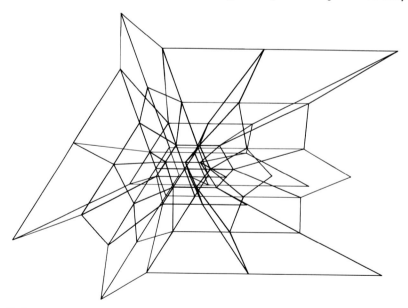

Fig. 5.6. Non-Euclidean three-dimensional grid, straight lines connecting vertices.

106

number of coordinates (let us say three; the non-Euclidean program Nonclid is for three-space), but each point also has a marker for the curvature in each direction in that space. These markers range from being simple +1s and 0s to being complicated functions of space and mass.

When we wrote Nonclid, Herbert Tesser and I first noticed that even a space of only ten unit-lengths in three dimensions has a thousand points, each of which had three coordinates and three coefficients of curvature. Moreover, few details could be observed in such a limited space; a grid of 100-by-100-by-100 (consisting of nine million numbers) would more than likely be needed to see any details of the structure. We chose to work with a grid of only 3-by-3-by-3 cubes, computing only these few vertices, and splining (interpolating) through these points for a continuous rendering of the space, hoping for both speed and detail in this way.

Our spline gambit was successful; when the figure was drawn with straight lines connecting the vertices, only the basic object was visible (figure 5.6), but when we continuously interpolated between these points with our spline algorithm, the real character and detail of the structure became apparent (figure 5.7). Most revealing was the function of the program that rotates the figure;

Fig. 5.7. The same grid with splines connecting the vertices.

when viewed from a different angle, a completely amorphous figure appears to be highly structured. In fact, the three-dimensional volume of complexly curved planes only comes into consciousness when smoothly rotated.

The most interesting space we examined is one where the coefficients of curvature are the same in each direction but change with location according to the formula that A, or B, or C is equal to the square root of the squares of the three coordinates added together $(A,B,C = \sqrt{x^2+y^2+z^2})$. In other words, the curvature at each point of this symmetrically curved space is a function of its location and space curves differently at each point in space. From the point of view of non-Euclidean viewers this space looks like a rectilinear grid of straight-edged boxes. However, when it is projected into Euclidean three-space, wonderfully collapsed and sprung curved objects appear (figure 5.8).*

Banchoff recently made an impressive computer visualization of a positively

Fig. 5.8. Straight lines and splines superimposed.

*Included on the disk are versions both with and without the spline. Nonlin (without the spline) will run fast enough on most personal computers so the user can see the structure. Nonclid (with the spline) will slowly sculpt out the complexly warped planes that define the true character of the space.

108

curved three-dimensional sphere in four-dimensional space in his program and film *Hypersphere*, made in collaboration with Hüseyin Koçak, David Laidlaw, and David Margolis:

> The ordinary sphere in three-space is the collection of points at a fixed distance from a given point. In four-space, a hypersphere is defined the same way, as the collection of points at a fixed distance from a given point. All the vertices of a cube are at the same distance from its center, so the vertices of a cube are situated on a sphere about its center. Similarly, all vertices of a hypercube are situated on a hypersphere.[5]

In central projection, a section of a hypersphere appears to us as a torus, a doughnut shape. Numerous such sections could be taken; three are shown in the illustration (figure 5.9). Cutting open bands in the tori allows us to see where they overlap. As the hypersphere rotates, the map projections of the torus-shaped sections seen on the computer screen separate, become linked, shrink to columns, fan out to flat planes, and ultimately exchange their position, so that the figure appears to turn inside out.

Magnificent new computer models of negatively curved space have been made by Charlie Gunn at the Geometry Supercomputer Project in Minneapolis, under the direction of William Thurston. In one sense this program is easier to understand in that it is in three dimensions instead of Banchoff's four; yet the Thurston-Gunn images are of non-Euclidean *spaces*, not surfaces. Moreover, negative geometry is harder to visualize than the more familiar positive geometry of the surface of spheres.

In Hexagonland, six hexagons fit around every hexagon. In Cubeland, where we all live, six cubes fit around each cube, one on the top, bottom, and each of the four sides of the cube. Counting cubes that just touch the central cube, there are twenty-six. Imagine a three-by-three-by-three stack; all the outside cubes touch the inside cube: one on each of the six faces, one on each of the twelve edges, and one on each of the eight corners. If ever you are in a space where more than twenty-six regular cubes can fit around a similar cube, you can bet you are in a non-Euclidean, negatively curved space. What happens if the square faces become pentagons with five edges, and the cube becomes a dodecahedron? Instead of six faces to cover there are now twelve, instead of twelve edges there are now thirty, and instead of six corners to touch there are

now twenty. Clearly many more units are needed.

The challenge in seeing the Thurston-Gunn illustration (figure 5.10) is to see the dodecahedron, not the pentagons, and to see all the other dodecahedra exactly nesting around it. Each unit has been compressed by being in a negatively curved space so that the normally flat angle between two faces of a dodecahedron has been sharpened to a crisp 90 degrees. That means that around every line there are four cells, eight at every corner, just as in Cubeland — except that our "cubes" have thirty edges.

The most mind-boggling fact about this tessellation of regular dodecahedra in negatively curved space is that it is the inside view of a single dodecahedron where the faces have been glued together. Thurston and Weeks explain as follows: in a video game when a character goes off the screen to the right, it

Fig. 5.9. Thomas Banchoff and associates at Brown University,
computer image of a hypersphere.
Three-dimensional "slices" of the skin are tori.

reappears on the left. In a sense, then, the left side and the right side are glued together, though we may see it as cut. Imagine the walls of a room glued topologically. Passing through the front wall, you return through the back. A dodecahedron has six sets of parallel walls (to the room's three). Gluing the six sets together, with the necessary little twist to make them fit, in effect induces a negative curvature in the system.

Interactive manipulation of non-Euclidean spaces in real time requires a substantial commitment in computer equipment and programming time, but it has been largely achieved, further enriching our consciousness of space. The visualization of space can now include the visualization of curved spaces, which may have exotic connectivity. Soon we may *see* that our physical space is so curved; Reichenbach's aspirations are no longer far-fetched.

Fig. 5.10. Charlie Gunn, a visualization of hyperbolic space from *Not Knot*. Every "cube" of this three-dimensional packing has the faces, edges, and vertices of a dodecahedron.

6.

Time *in* Space: Three Enigmas of Space

Space is still the great mystery. It is not just a mystery like the oceans were two hundred years ago, in that we do not know what is *over* there. Rather, the bigger mystery is what is between here and there. When I talk to physicists and mathematicians, I always hear their reverence for space, a reverence complicated by an annoyance that it is so strange. The three biggest questions in physics — how to get something from nothing, why time is an arrow, and how to depict places where quantum effects can occur — seem to reduce to "what is space?" To answer this question is to answer the other three. Since space is four-dimensional, the question "what is space?" will be answered when we truly understand the properties of the fourfield.

No doubt space is a problem we humans have made for ourselves, a conceptual problem created by an atavistic brain formed to search for game in the African savannah. Space does not exist; it is what is *not* out there. To be sure, I am not next to you as you read this, and there are many obstacles between us: chairs, water, air. But imagine every one of these obstacles removed; then there is nothing between us. We cannot usefully think of space like that, and so fabricate inevitably faulty metaphors for space: space is like land, space is like air. Surely it is such metaphors that are the problem; yet knowing this history does not really take the bite out of our current paradoxes of space.

How can something be made out of nothing? This is the first great mystery of space. At the time of the Big Bang, in the vicinity of black holes, at the smallest levels of experimentation, matter is created out of empty space. For example, Stephen Hawking's generally accepted theory is that the extreme gravitational force near black holes can rip particle pairs out of empty space-time, sending one of the pair into the black hole and the other radiating out into space. There is nothing out of which these particle pairs can be made

except empty space. According to the standard theory, this is possible because empty space is really full — full of *almost* particles, virtual particles, that come into being just when you need them and conveniently go away when you do not. Defensively, physicists are always quick to mention at this point that the theory of virtual particles as force-mediating entities (which has the unfortunate, illogical end result that duty binds us just to get used to it) is one of the best-tested and most successful theories in all of physics. These protestations make me suspicious.

Taste aside, the theory creates a problem. If space is full of virtual particles, with mass, or energy, or momentum, then space itself should have a gravitational effect on the universe as a whole. As Larry Abbott states, this effect can be quantified, and even with the most conservative of estimates and the most reasonable of assumptions, the gravitational effect calculated is absurdly high, not even remotely possible in the universe of our observation:

> Although virtual particles cannot be detected by a casual glance at empty space, they have measurable impacts on physics, and in particular they contribute to the vacuum energy density.
>
> If the vacuum energy density . . . were as large as theories suggest, the universe in which we live would be dramatically different, with properties we would find both bizarre and unsettling.[1]

The sum total of gravitational effect of the space is labeled the *cosmological constant.* This term is a number that defines the overall curvature of space: a positive number means space is positively curved, a negative number means space is negatively curved, and a zero means that space is flat.* The cosmological constant can be thought of as the sum of several components: (1) effects calculated from known particles and virtual particles; (2) effects estimated from particles predicted but not discovered; (3) particles that may exist and are not yet predicted; and (4) the effects, if any, of truly empty space. Assuming that these effects are cumulative, rather than self-canceling, the cosmological constant might have a value of $1/(1 \text{ kilometer})^2$. But limits can be placed on the

*Newtonian theories of gravity, which assume space to be flat, work perfectly when calculating the throw of an artillery shell, and Einsteinian theories, articulating a curved space, work perfectly when shooting a rocket to intercept a distant planet. But the curvature of the universe as a whole, as codified by the cosmological constant, is the problem.

cosmological constant by attempting to observe these gravitational effects directly in the curvature of space-time in surveys of the galaxies:

> Our theoretical estimate suggesting a magnitude larger than 1/ (1 kilometer)2 is incorrect by, at least, an astonishing factor of 10 to the 46th power. Few theoretical estimates in the history of physics made on the basis of what seemed to be reasonable assumptions have ever been so inaccurate.[2]

Such arguments confirm the paradox. The filling of space with virtual particles is a fiction that only appears to explain things. Taken at all seriously, it leads to bigger problems than it solves. The question for physics is how something is made out of nothing, and fudging the question by inserting into the paradox an entity that is both something *and* nothing is a distraction.

New "inflationary" models of cosmology by Alan Guth and others recognize and attack the "something from nothing" problem (as well as address other problems of the standard Big Bang theory). In the inflationary model, the universe goes into a sudden, early, very rapid expansion. This expansion adds space to the universe beyond what could be obtained from an expansion due only to the natural cooling of the infinitely hot universe at the Big Bang. Any matter in such an inflationary region is quickly left behind. Yet the volume of space is vastly increased, and as the basic energy per unit-volume must remain constant, the result of inflation is that the total energy is increased. That energy ultimately becomes matter, even more matter than before. "The Universe is the ultimate free lunch," is Guth's often repeated statement. Creation ex nihilo is recognized as a property of space by physicists who feel that our metaphor for space is incomplete without it.

As we have seen, considering space to be the ubiquitous field of virtual particles makes the problem of the cosmological constant worse. Yet even without the contribution of the field of virtual particles, the cosmological constant is still calculated to be much too big. It is observed to be very close to zero (making space as a whole just about flat), yet everything in the universe adds something to it. A new concept of space championed by Sidney Coleman could be the answer. Coleman imagines a completely frothy space of wormholes to other universes, which has the effect of regulating gravity in the universe.

Abbott and others have proposed various schemes to patch up the theory of gravity in the large-scale, governing mechanisms in the field that would dampen out gravity and flatten out space. The problem with all these mechanisms is

114

that there is no frame of reference to which the adjustments can be made. Coleman's audacious idea is that space is thoroughly filled with minuscule wormholes that connect us to other empty, but large, universes, and that these connections maintain the observable universe as we know it.

Solutions to the Einstein field equations by G. V. Lavrelashvili, V. A. Rubakov, and P.-G. Tinyakov, and by S. Giddings and A. Strominger have shown that such wormholes could exist in Euclidean four-dimensional space, the fourfield. They would be of quantum magnitudes, which means that they are small — way, way below the size of an elementary particle — and exist for too short a time to be measured. No information can be passed through them; we will never be able to see through them into another universe. But just because they exist, adjustments to the cosmological constant are continuously being made, maintaining a flat universe. Coleman proposes that adjustments must perpetually be made to all the other cosmological parameters as well: the fine-structure constant (the small size at which events can only be defined by quantum physics), particle masses, and the power of gravity itself, for example. These wormhole space connections to other universes are the regulator valves of our universe's existence.

If, in the early stages of the development of the universe, there existed the proposed inflationary period, then there was also at that time a large cosmological constant, and it worked as it was supposed to work. All the energy density of the universe added up to a large positive cosmological constant, producing an antigravity effect due to the fact that energy pressure, not mass, predominated. This type of cosmological constant would indicate that the universe would undergo an extra massive accelerating expansion, which it did. The problem now becomes, How did that space turn into the very different one we now have? What is the space bridge from that inflationary, mass-generating, positively curved space to the gravity-sapping, flat, zero-cosmological constant space we observe? These questions are perplexing to theorists, but it might well be that creation out of nothing, inflationary periods of space, and the mystery of the cosmological constant are all bound within the mysterious properties of wormholes in Euclidean four-space.

Why does time go in only one direction? The second mystery lies in the fact that, in the four-dimensional grid depicting space-time, the dimension we ascribe to time is not really identical to the other three. In other words, when

we apply Euclidean four-dimensional geometry to the space-time of the special theory of relativity, there is not a perfect fit.* Time is a single-headed arrow, not a two-headed arrow like the three other dimensions, and so space-time is not an absolutely symmetrical four-dimensional field after all. Of course, in one sense, this is not a mystery at all, and we all have accepted our fate: though we can move forward and backward in any spatial direction, not one of us really expects to get any younger. But after years of looking at xs, ys, zs, and ts in four-dimensional equations, it does begin to look as if they should be qualitatively similar entities, and it then begins to be strange that these algebraic terms are not more equal in their physical manifestations.

The following thought experiment, by David Layzer, presents the mystery in more concrete terms. A perfume bottle is opened in a still room. Soon observers in the room smell the perfume. Eventually all the perfume in the bottle has evaporated and there are perfume molecules equally spaced throughout the room. Suppose a film were made of the microscopic details of the evaporation and propagation of the perfume, following individual molecules during the entire processes. No physicists would be able to tell, from looking at short clips, if the film were running forward or backward. Indeed, it would violate no laws of molecular motion for molecules to collide with one another in such a way that molecules in the far corners of the room could work their way back into the perfume bottle. But no matter how long we wait the perfume bottle will not gradually refill with the perfume. There is no physical, local reason why this experiment is not time-reversible, or time-symmetric (to use a more geometric term). In general the laws of thermodynamics are time-symmetric. That time is a single-headed arrow is

*To recapitulate: In chapter 1, we saw that four-dimensional geometry exists apart from its applications in physics, and in that sense the fourth dimension is not necessarily time. Moreover, if we do choose to apply four-dimensional geometry to physics, a good case can be made that the geometry is more "real" than the observations since it is invariant. In chapter 3, in my birdcage thought experiment, I suggested that four-dimensional geometry was real in another sense, in that its projection on itself generates the situation we call space-time. In this view, time is not the fourth dimension, but rather the result of the collapse of the fourfield into three-dimensional space and a residue. Now we refocus on a more traditional interpretation: space and time are real and are modeled with a four-dimensional geometry. However, this geometry is not Euclidean four-space, what I have been calling the fourfield; for in Euclidean geometry distances are measured by the Pythagorean theorem $d = \sqrt{x^2+y^2+z^2+t^2}$, whereas in the four-dimensional geometry of special relativity (sometimes called Minkowski space) $d = \sqrt{x^2+y^2+z^2-t^2}$.

116

something we attribute to time in general, not to a specific local event:

> When events are interpreted according to the most fundamental
> laws of physics, however, the distinction between past and future all
> but disappears. Intuitively we perceive the world as being extended
> in space but "unfolding" in time; at the atomic scale the world
> is a four-dimensional continuum extended in both space and time.
> We assign special significance to a particular moment, the present,
> which we view as the crest of a wave continuously transforming
> potentiality into actuality and leaving in its wake the dead past.
> Microscopic physics gives no special status to any moment, and it
> distinguishes only weakly between the direction of the past and
> that of the future.[3]

Physicists associate this global property of time with entropy, the loss of focused heat and matter. The universe starts with maximum heat (maximum density) and evolves toward minimum heat (extended distribution of matter). I am reminded of artist Robert Smithson's wonderful thought experiment illustrating entropy: Fill a sandbox half with white sand, half with black sand. Have a child run clockwise around the sandbox, gradually mixing the white and black sand. Having the child run *counter*clockwise, however, only further mixes the sands, and will never return the sandbox to its initial condition.

In physics, heat and "information" are connected. Although I recognize that most physicists see loss of focused heat (increasing entropy) to be equal to loss of information, I prefer Layzer's contrary interpretation: information is generated by heat loss. An example is a lump of sugar dissolving in a cup of hot tea. As the liquid cools, losing its ability to do useful work (warm the tea drinker), the sugar lump is distributed throughout the tea and the information contained in the crystalline geometry of the lump is lost. The classical discussion ends here, but Layzer has pointed out that information is also generated in this process: the location of the sugar molecules, their history of getting to those positions. Layzer has calculated that the information (defined in a mathematical way as binary digits) lost is equal to the information gained. While it is true that the primordial fireball at the beginning of time is cooling off and losing energy to empty space, if Layzer is correct, then the information component of entropy provides no clear arrow. Furthermore, gravity collects and refocuses the "lost" energy into new stars, and possibly into a new fireball indistinguishable from the original.

Associating the arrow of time with entropy seemed at first reassuring; now it is less satisfying. And there still is the question of how this global property (a temporary arrow of entropy, an arrow of the conversion of information) arises from its opposite local property (time-reversible molecular dynamics). By what mechanism is this global property affected in the local case? To avoid that question defies logic, accepts invisible forces, and evades the mathematics of space.

Recently physicists have recognized five arrows of time, and are answering the related question of why these five arrows all point in the same direction: the cosmologic arrow, the thermodynamic arrow, the psychological arrow, the electromagnetic arrow, and a relatively insignificant technical arrow concerning asymmetry in the breakup of a laboratory-created particle called the K meson. The last arrow is beyond the scope of everyday experience, and some feel the electromagnetic arrow can be finessed with complicated arguments.

The main question is, Why do we see the universe getting bigger and cooler and gaining entropy (the cosmological arrow) while we see entropy in closed systems (the thermodynamic arrow) while we perceive everything getting older (the psychological arrow)? Stephen Hawking has answered this question to his own satisfaction with the more and more frequently used anthropic principle, which states that conditions in an antientropic universe, where everything is rushing together to a cosmic big crunch, are not conducive to life. There are less sympathetic ways to state the principle: Of course we see the universe as it is; if we didn't we would not be here to see it that way. Such restatements reveal an uncomfortable tautology.

It is too clever by half: Why did you sleep with my mate? asked the cuckold, and the answer given is, Because the universe is expanding and then atoms were created and then stars synthesized organic molecules and so on. Moreover, the cuckold is told, the universe, complete with unfaithful mates, is the way it is because I exist. No spouse would be satisfied with so smug an answer.

The collecting together of true facts — that we exist, that the universe expands — does not explain away the fundamental paradox that time-symmetric events that take place in our space are mysteriously pushed along a single time direction.

The third, and perhaps the final, greatest mystery of space results from the ambiguous results of the second: on occasions the local properties of time seem

118

to dominate and time does seem to run backward, is at least one way to explain quantum effects. Or one could say, no one knows how to depict a realistic space in which quantum effects could occur. The most gripping experience of quantum effects is that presented to us by the Bell inequality experiments discussed in chapter 2. Bell inequality experiments are being repeated in numerous places (most recently by Alain Aspect in Paris), in ever more concrete ways, on ever larger scales. No classical space-time explanations of them are possible. Clearly something must be very wrong with our geometry of space.

In these experiments, delayed choices are made that cause results backward in time — before the choices were made. An alternate interpretation, one equally counterintuitive, is that particles do not exist in any concrete way until they are observed. Thirdly, some physicists actually refer to the universe splitting into two universes each time such a quantum effect is observed, with the probability of you and I being in one or the other universe a probability of the quantum effect, which seems more of a poetic expression of their reverent confusion than a practical program to solve this problem of quantum space. Finally, it could be the case that space has a more complex kind of connectivity than anyone thought. In this view, each location in space is connected to each adjacent location, like bricks in a road, and it is also true that each location in space is adjacent to every other location in space, like a television bringing any other part of the world into your living room. The conceptual problem is to accept that, unlike the television images, which are composed of electrons that take time and energy to physically transport, the two spaces really are adjacent on some occasions but not on others, and that this multiconnected space is not just a rephrasing of other options but a new reality of space itself.

Abbott explains it this way. Look at a particle as it undergoes a quantum tunneling through a barrier (slips through a quantum wormhole). As it approaches the barrier, it looks like a ball governed by the laws of motion of the regular space-time of special relativity, and after the ball leaves the opposite side of the barrier it also is governed by those same laws. But while it is in the quantum tunnel, things are different: there is a skip in time, as if no time takes place.

Hawking first showed that this situation can be accurately modeled if the space of the tunnel is depicted in Euclidean four-space. All that is required is to take the units of time and measure them in units of i, the square root of -1. This turns the data of the event into Euclidean four-space; the computation is completed in that space, and then the results are converted back into regular

three-space and time. You have to be clever at gluing the before, during, and after spaces together; you have to pretend that all this takes place in a space without gravity; and you just have to do it and not worry about what imaginary time really means. With these conditions in place the Euclidean four-space calculations work fairly well. Thus the peculiar connectivity implied by quantum events can be said to take place in Euclidean four-space where time is measured in units of $\sqrt{-1}$.

According to the twistor theory of Roger Penrose, it is the *projections* of complex spaces with both real and imaginary parts that are the key to their power. Remember that a projection can be thought of as a shadow, say the shadow of a box made out of steel rods, which forms the pattern of a complicated, concentric two-dimensional design. Various projections of complex spaces are related to one another in precisely the way that the theory of relativity tells us moving frames of reference would be related to one another, making a perfect match with special relativity. In other words, we can convert from the quantum space of Euclidean four-space with imaginary time to the three-space of relativity with real time by the mathematical technique of projection. It is remarkable that complex spaces that work well in describing quantum events also work so well in this completely different realm of physics, and that the spatial distortions of quantum events can be integrated into the spatial distortions of special relativity. In Abbott's example, both the ball before and that after the tunneling are projections from the higher-dimensional space in the tunnel. Penrose has the hope that since twistor space works for both special relativity and quantum mechanics it might ultimately be made to work for the general theory as well, finally integrating physical space and quantum events.

To accept the philosophical implication of Penrose's theory we have to distinguish between reality and experience, as we did in Einstein's cave. By a wicked conspiracy of language "experience" is associated with real time (the single-arrowhead type), and "reality" (any consistent philosophy of the universe) is associated with imaginary time (the one measured in units of $\sqrt{-1}$). It is not only that our experience is limited by the coarseness of our senses or the bluntness of our machines; it is that in principle we do not experience reality, but the projection of reality. The confusing mechanics of shadows mediate between reality and experience. You do not project up to the artificial situation of Euclidean four-space just to do a calculation; rather, you project down from that real case to discover the specific nonquantum situations we find ourselves

120

in. The before and after photos are no longer seen as unrelated or discontinuous, but as different shots from different angles of a fully dimensional thing.

Perhaps Penrose's projections of complex spaces are too technical to be appropriated by amateurs, but I cannot help feeling confirmed in my pet theory (discussed in chapter 3) that projected Euclidean four-space is the answer to these three paradoxes of space. In Euclidean four-space time is the two-headed arrow of quantum events, and that two-headedness is maintained in projection but lost in slicing. And if my birdcage thought experiment has merit, space-time itself — the vacuum, the source of the cosmological constant and its progeny of matter — space-time is rooted in the projective geometry of Euclidean four-space. No one really knows the answers to these three enigmas of space: the source and maintenance of matter, the arrow of time, and the full spatial depiction of quantum events. But it is beginning to look like the answers lie in the mysterious properties of the fourfield, projected or not.

7.

Exebar Speaks!

The most acceptable statement about the relationship between art and science is that science precedes art. Mathematics and science continue on their own momentum, one discovery in experiment or theory leading to others. Then artists learn of these new discoveries in science and make people fully aware of these new understandings by allowing us to experience new definitions of existence as reality.

But I have argued that a truer statement about art and science, although, granted, one more difficult to prove, is that art precedes science. Perceptions are emotions; one cannot have a new scientific perception unless one is ready to experience a new emotion. Artists are in the business of creating new emotions. In chapter 2, I gave the example that atmospheric perspective preceded geometric perspective, which then gave impetus to generalized projective geometry. The artistic manipulation of color substantiated the notion that air is a low-density solid that filters light, and so can be analyzed by geometry.

At the time of the impressionists, space in science was the ether, precisely that airlike, low-density solid with a fixed-coordinate geometry that Renaissance perspective hypothesized. After impressionism the potential of seeing smoke and mist as beautiful or powerful vortexes of sensation impinging on the individual always exists, implying a different definition of space, and it is just during this time of the formulation of impressionism that the ether begins to be abandoned in favor of the field. Light, electricity, and magnetism were shown by James Maxwell to be governed by the same laws and operate in the same field space.* Moreover, the famous Albert Michelson–Edward Morley 1887 experiment measuring the speed of light in perpendicular directions showed that the ether was neither attached to the earth nor something the earth moved through. This paradox led Einstein to postulate his more abstract, discontinuous, and superimposed spaces in 1905. Maxwell's work and the Michelson-

*The Maxwell field equations were published in 1864. Twelve years later he published his classic *Matter and Motion*; also about this time he made contributions to the *Encyclopedia Britannica*.

Morley experiment are usually cited as the main sources for Einstein, but I am waiting for the time when some scholar finds the lost Einstein letter that says he was made comfortable with such a notion after looking at a painting by Monet (Sisley, Pissarro, Van Gogh, Derain) in which the light moving across the water clashed with the light coming from under the bridge.

It is progress in art that leads to the realizations of science and not the other way around. True, it is a handicap for artists to be ignorant of developments in mathematics and science — a greater handicap than most artists realize — but it is even more foolhardy for scientists to insulate themselves from art. I began this book by claiming that artists develop when they pretend to be scientists. Now I want to say that scientists should pretend to be artists. After all, Newton considered his science to be of minor importance compared to his theological poetry, and Poincaré (who may yet turn out to be the greatest mathematician of the nineteenth century) embroiled himself in the art world of his day. Poincaré's writing is filled with the contemporary "relativity" aesthetics. At the turn of the century, Japanese and African art flooded into France, and these greatly admired, alternative traditions seemed to confirm a long-standing search for a Noble Savage, and to prove that the European point of view was arbitrary. Poincaré's philosophy of relativity, and his mathematics, which is its embodiment, were based on his taste for eclecticism. As a service to science, then, I offer myself, my story, how I got this way.

My first New York artist friend was Howard Buchwald. We met when we were both undergraduates in college. He was an art major at Cooper Union and I was a Columbia literature major, still tentative about being an artist. That Buchwald could discuss Sultan Muhammad and Mir Musavvir as though they were the latest names in *ARTnews*, instead of miniaturists working in Persia in the early part of the sixteenth century, strongly suggested to me that the tradition I was supposed to learn about mixed New York painting with exotic and esoteric traditions of the East. Other artists of my generation also love Oriental art. In graduate school at Yale, my friends and I made pilgrimages to New York to see important shows, and the show that had to be seen, more than any other, was one of Indian painting at the Asia House curated by John Kenneth Galbraith. Still later, other exhibitions of Oriental art were major influences. *A King's Book of Kings*, Persian miniatures at the Metropolitan Museum of Art, acted as a lever to move Robert Zakanitch from his earlier minimalist work to

the style for which he is now known. That show was also a major inspiration for Joyce Kozloff, whose large paintings and colored-pencil books of that period were based on Iranian art. Japanese art, especially the art of the kimono, seen in numerous shows during the seventies, was important for John Schnell, Bob Kushner, and Miriam Schapiro, who devoted a fifty-foot-long painting to the subject of the kimono. And in David Hockney's recent lectures he passionately talks about the influence of Chinese scroll painting as a source for the changing perspectives in his paintings and photograph collages.

Now, I have a special affinity for Oriental art (figure 7.1) because I grew up in Japan, Okinawa, and Iran. My earliest memories take place in Japan just after World War II, when I must have been about three. I remember visiting Papasan, who had a small shop on an unpaved street. Inside, there were tatami mat floors and a large wooden chest with many small drawers. The old man would pull out packets of cotton batting and inside would be jade or small precious gems at which a small boy could gaze with reverence.

I also remember an experience I had when I was fourteen in Teheran. Along with two experienced Iranian climbers, another American boy and I crossed the Alburz Mountains early one spring. Climbing in the foothills before dawn we saw dry, dusty, concave stretches, which alternated with convex passageways of dark trees filled with the sound of running water. Later, a long and brutal climb over the top of the ridge gave way to a beautiful, unexpected, and dangerous expanse of snow. Passing through the valleys on the other side of the ridge, we saw the ruins of ancient palaces of the Shahs and met villagers who said we were the first to cross the mountains that spring. Most memorable of all, however, was the experience of waking up the morning after our return and seeing familiar things — carpets, breakfast settings, gardens — as though my perceptual capabilities had been magnificently enhanced. Colors, shapes, densities, weights, tastes, everything seemed more real than real.

I returned to Japan with my wife in 1972 for a summer visit. Although we were genuinely impressed with Kabuki, the temples of Kyoto, and all the other *official* cultural riches of Japan, we especially loved looking at kimonos in the department stores. Our thrill was in the intimacy of the experience, and the discovery of a vast tradition. There were both figurative and geometric kimonos, made in a variety of fabrics and mixed with various obi cloths. Kimonos of different seasons have greatly different color combinations and feelings, and different makers have different sensibilities. Yet characteristic of everything we

124

Fig. 7.1. Leaf from a Shah-Nameh, c. 1525–30, representing a tradition of spatially rich painting.

125

saw were a juxtaposition and a superimposition of different elements, especially different patterns, that have no counterpart in Western art of any medium.

Each of these experiences indicates a general, subliminal visual training, one which, by avoiding the reiteration of the viewer's time and place, deemphasized the viewer and instead urged the viewer to lose himself in things seen sequentially (gems, breakfast settings, obi cloths), whether or not such serial vision builds toward a coherent and unified picture of a whole place at a specific time.

According to Stuart Cary Welch, a scholar and the curator of *A King's Book of Kings,* such eclectic vision is built into the Iranian artist's method of working.

> Most ateliers contained an inherited store of tracings, stencils, pounces, drawings, and miscellaneous scraps — an accumulation of "trade secrets" that may have included motifs derived from exotic sources (Chinese, Indian, European) as well as from earlier phases of the local tradition. If a less inventive or slightly lazy artist wished to paint a picture containing a dragon, he probably found a dragon near at hand to copy. When it was a painted or drawn one, he traced it onto a piece of transparent gazelle skin, then pricked along the outline, thus making a pounce. (At times, too, he simply pricked the original drawing or painting, after placing another sheet of paper beneath it, but his procedure was deemed reprehensible.) He next laid the pounce on the picture in progress and rubbed powdered charcoal through the pinholes. The resulting somewhat rough outline of a dragon would be reinforced with brush and black ink, and corrections made in white.[1]

> Iranian paintings seldom have single centers of interest. Their compositions do not say, "look at this hero slaying a dragon!" Rather, they urge us to go beyond the narrative subject to follow rhythms, shapes, and colors sequentially. While some Iranian paintings may strike us forcefully at once, and then — their message conveyed — release us, others invite our eyes to move from one element to the next almost endlessly: from a prince to a princess, pausing for a moment to examine the arabesque on her crown, to a flowering shrub nearby, then onward to a sward of pleasing tufts, a sensuous stream, or a group of convoluted rocks. It is better not to look at all than to hurry.[2]

The reason that *I* loved Oriental art was because it emphasized the discreteness of vision — a habit of seeing that seemed especially natural to me, having been brought up in such a discontinuous confluence of cultures. But why should

126

artists of my generation who have not lived in Japan and Iran be so captivated with a way of seeing that is alien to our artistic traditions? The beginnings of an answer can be found in Leo Steinberg's book *Other Criteria: Confrontations with Twentieth-Century Art* (1972). All previous paintings (Steinberg only discusses Western painting) are either a window or a mirror of the world, where the viewer stands erect "toe to toe" with the scene. But in the fifties, especially with the work of Robert Rauschenberg, says Steinberg, the paintings become "the flatbed picture plane," making the "painted surface . . . no longer the analogue of a visual experience of nature but of operational processes." Like the Iranian artists, Rauschenberg also uses pounces, in the updated version of chemical transfers from printed images. But it is not this superficial similarity of method that connects us to Persian painting through Rauschenberg. Rather, as suggested by Steinberg, the print medium, with its multitude of disconnected images imploding on the individual consciousness, is the true subject of Rauschenberg's work. Oriental art with its heroic eclecticism may be alien to our artistic traditions but it is not at all alien to our contemporary experience, where images are acausally collected without smooth transition.

Either Steinberg did not extend his argument to its logical conclusion or he wished only to talk about our elders, because the powerful medium impacting our consciousness and our sense of ourselves is television and its illusion of spatial wormholes. Oriental art is an art of spatial wormholes, and as such is a natural world to those trained to see by television. This would be true of people in my generation, whether or not they had my experience of never having lived on any one continent for more than four years until college.

My early works were self-conscious homages to Japanese and Iranian art. Some can even be considered to be travelogues composed of kimonos, moss gardens, Shinto shrine architecture, and the pictorial techniques of woodblock prints, as in *Tonikuni* (color plate 2). These works use the color techniques of Oriental art: contrasting light-valued hues juxtaposed, lines of color threaded through background fields, optical mixing of color (placing together of small bits of pure color that blend in the eye). They also capture the spatial complexity in Oriental art. Often, the paintings are divided into three parts. On one side overlapping sprayed hexagons, for example, might form a frontal and relatively flat space. Low-relief space — cubistic space — would fill another area. And perspective space, defined by intersecting planes of angle shapes, would define a third area of the painting. Every depiction of space implicitly

Color Plate 1.

Untitled, 1970, acrylic on canvas, 70″ × 54″,
collection of Bruno Bischofberger, Zurich.

Color Plate 2.

Tonikuni, 1972, acrylic on canvas, 70″ × 140″,
collection of the North Carolina National Bank, Charlotte.

Color Plate 3.

132

Untitled, 1973, acrylic on canvas, 70" × 140",
collection of the artist.

Color Plate 4.

Untitled #8, 1976, acrylic on canvas, 56" × 70",
collection of the artist.

134

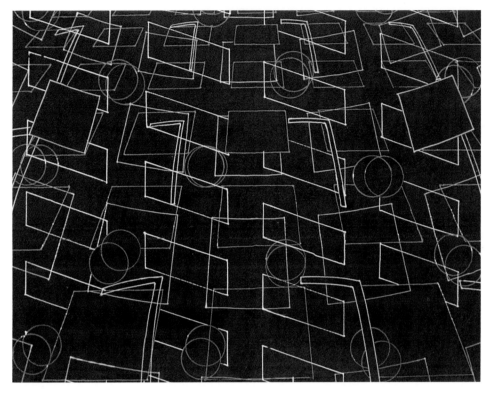

Color Plate 5.

Untitled #21, 1970, acrylic on canvas, 56″ × 70″, private collection.

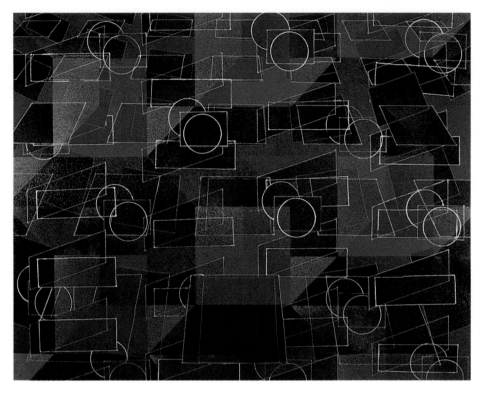

Color Plate 6. Untitled #6, 1976, acrylic on canvas, 56" × 70",
collection of Mark and Jessica Lichtenstein, New York.

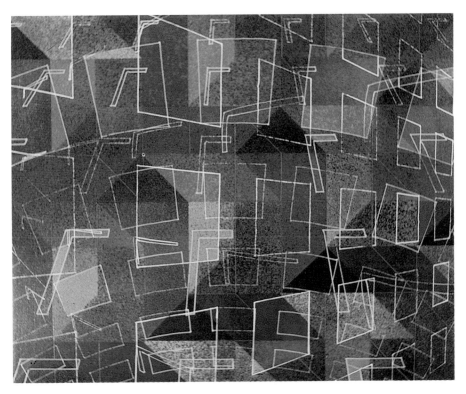

Color Plate 7. Untitled #3, 1979, acrylic on canvas, 56″ × 70″,
collection of Dr. & Mrs. Schnipper.

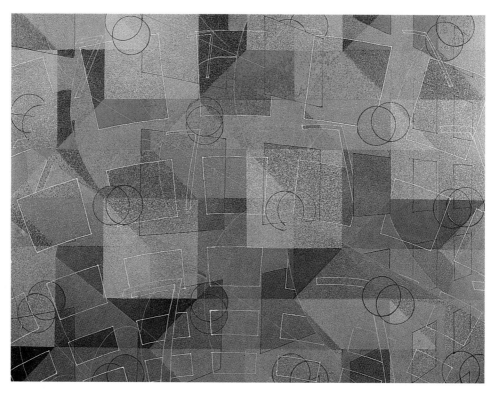

Color Plate 8.

Untitled #3, 1978, acrylic on canvas, 56" × 70",
collection of Marcel Laitowitch, Basel.

138

Color Plate 9.

Untitled #15, 1978, acrylic on canvas, 56" × 70",
collection of Eileen and David Peretz.

Color Plate 10.

Untitled #20, 1978, acrylic on canvas,
56" × 70", collection of Eric Rudin.

140

Color Plate 11.

Untitled #7, 1979, acrylic on canvas, 56″ × 70″,
collection of Max K. Robbin.

Color Plate 12.

142

Untitled #8, 1979, acrylic on canvas, 70" × 120",
collection of the artist.

Color Plate 13.

Untitled #20, 1979, acrylic on canvas, 72" × 166",
collection of the artist.

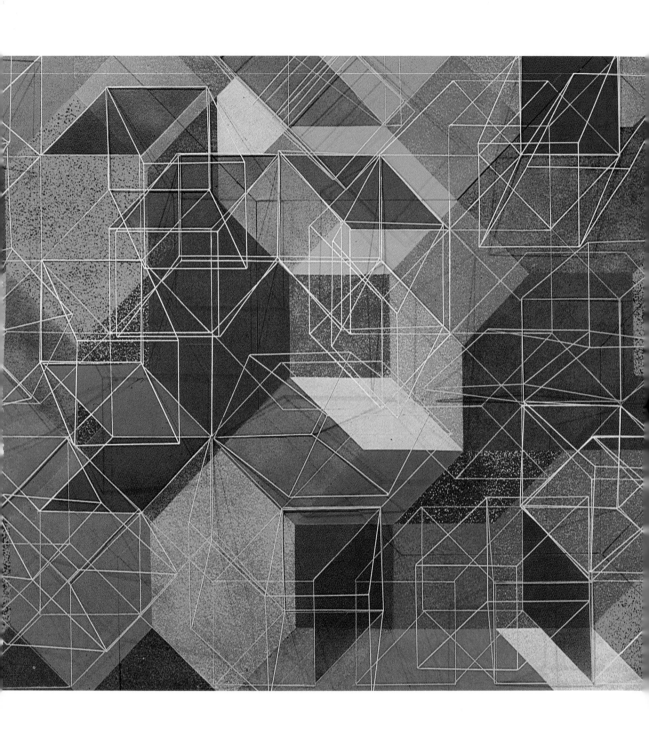

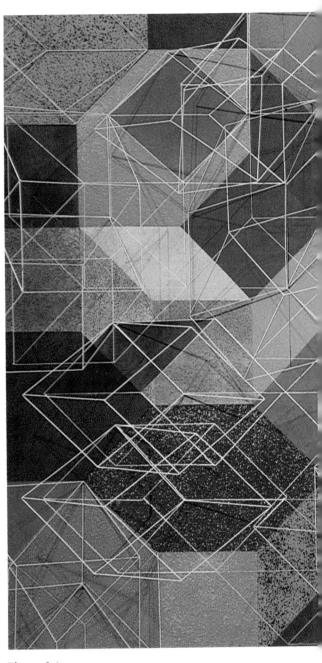

Color Plate 16.

148

Color Plate 14. Untitled #18, 1979, acrylic on canvas, 56″ × 70″,
Anonymous Gift, Orlando Museum of Art.

146

Color Plate 15. Untitled #2, 1980, acrylic on canvas, 56″ × 70″,
private collection.

147

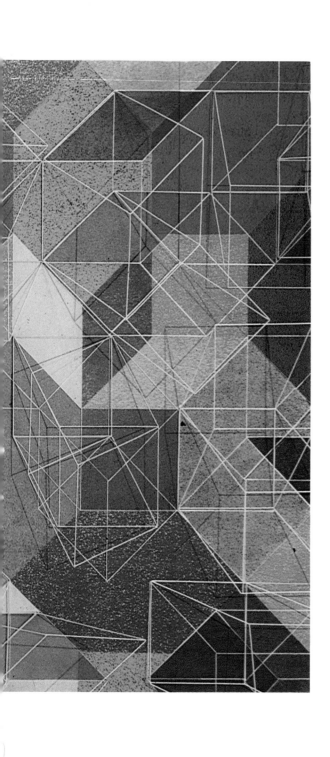

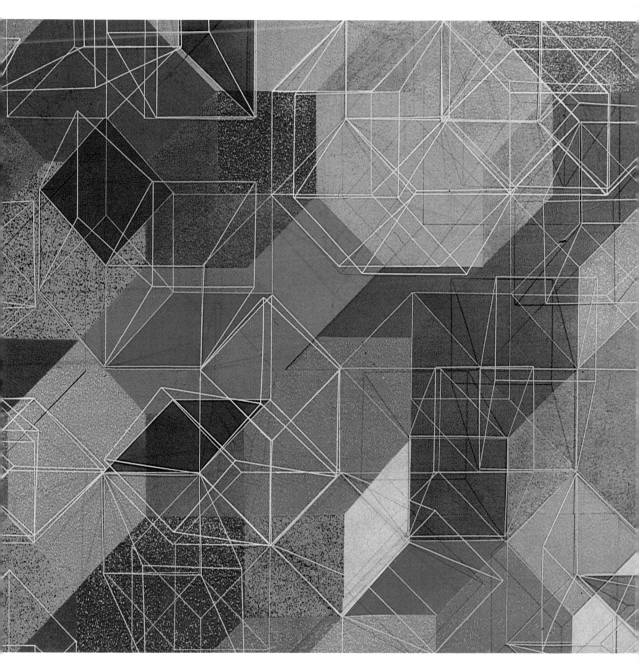

Fourfield, 1980–81, acrylic on canvas with welded steel rods, 8.5' × 27' × 1.5',
General Electric Co. Corporate Art Collection.

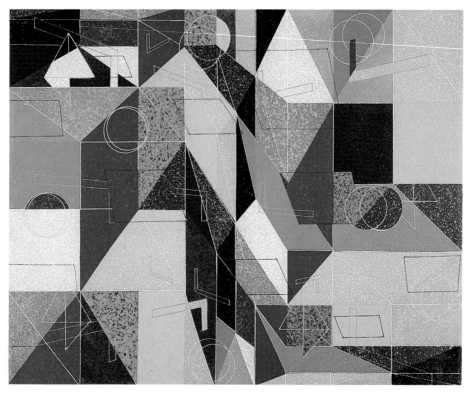

Color Plate 17. Untitled #13, 1980, acrylic on canvas, 56″ × 70″, collection of the artist.

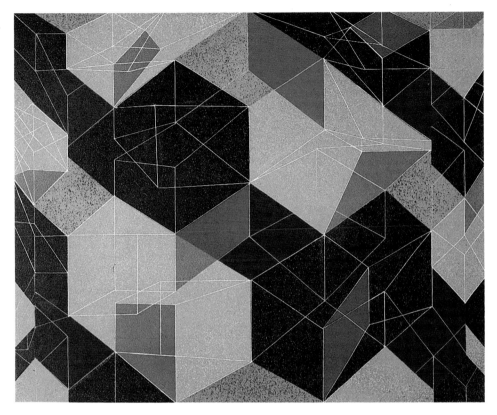

Color Plate 18. Untitled #3, 1981, acrylic on canvas, 56″ × 70″,
collection of Max K. Robbin.

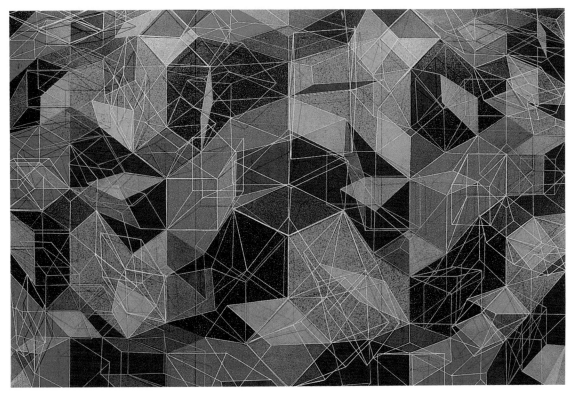

Color Plate 19.

Lobofour, 1982, acrylic on canvas, 8' × 12' x 2',
collection of the artist.

154

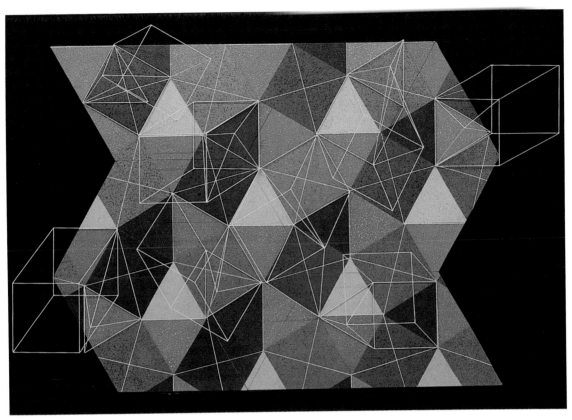

Color Plate 20. *Simplex #9*, 1983, acrylic on canvas, 5′ × 7′ × 1′,
collection of the artist.

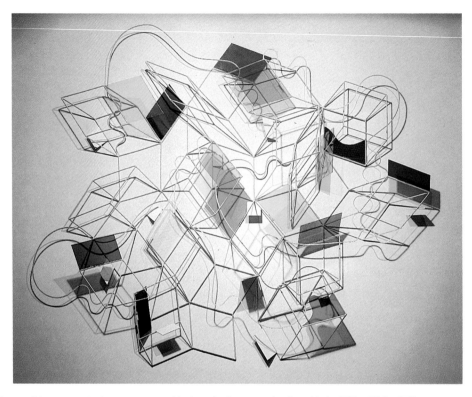

Color Plate 21. Untitled #10, 1986, welded steel, plastic, and colored light, 70″ × 70″ × 15″,
collection Coca-Cola USA, Atlanta.

156

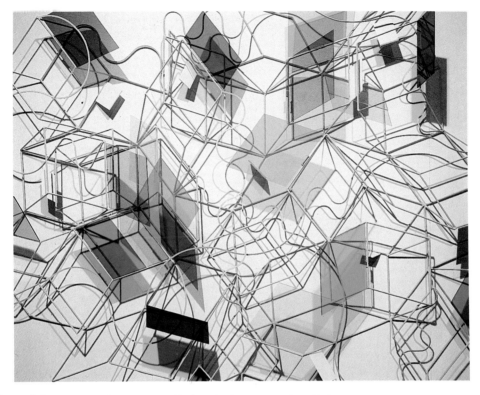

Color Plate 22. Untitled #3, 1987, welded steel, plastic, and colored light, 70″ × 70″ × 15″, collection of the artist.

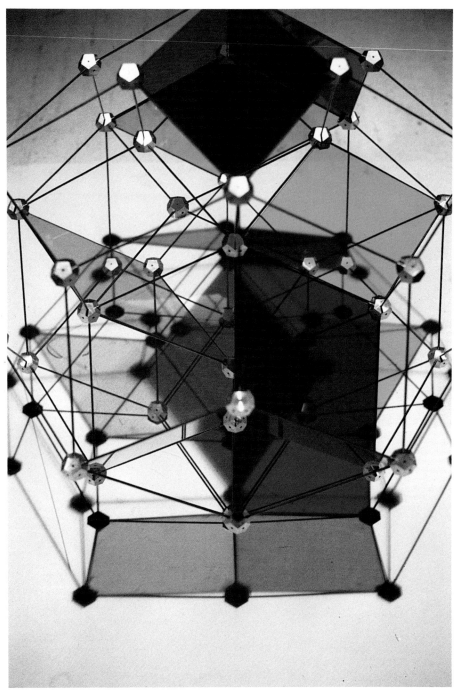

Color Plate 23. *Quasicrystal Sphere,* 1989, aluminum, stainless steel, and plastic, 30" diameter, collection of the artist.

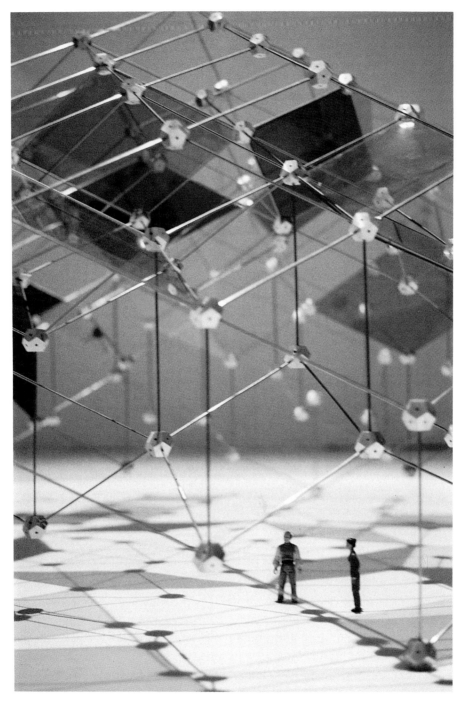

Color Plate 24. *Quasicrystal Dome*, 1990, aluminum, stainless steel, and plastic, 6' diameter, collection of the artist.

situates the viewer, and thus the possibility exists to put the viewer in more than one place at the same time by having disparate spaces exist in the same work of art. This multiplicity of spaces is what I saw in Persian miniatures and Japanese woodblocks.

There are profound psychological ramifications for the viewer who empathically sees those spaces and learns to live in them by that act of seeing. Our view of the inside world is all mixed up with our view of the outside world, and in these new spaces the "self" becomes a four-dimensional entity. Reconsider the concept of the self in contemporary painting in the United States. The last American painting that attempted a direct definition of the basic unconscious nature of human beings was abstract expressionism. Minimalism, pop art, and photo-realism all attempt to suppress or confound insight, but abstract expressionism is a learned and ardent debate on the subject of the self. It failed, however, to produce a concept of the self that was useful for its practitioners or for the artists who followed.

The first concept of the unconscious investigated by abstract expressionism was Jungian: that the unconscious is a storehouse of ancient symbols. These images and symbols, found in ancient art as well as in contemporary primitive art, are innate and universal, not a function of the particular society in which they are found. For artists such as Adolf Gottlieb, Hans Hofmann, Jackson Pollock, and Mark Rothko, it was not the formal inventions of primitive art but instead its content that was a source. Rothko has stated that

> [the myths of antiquity] are the symbols of man's primitive fears
> and motivations, no matter in which land or what time, changing
> only in detail but never in substance, be they Greek, Aztec,
> Icelandic or Egyptian. And our modern psychology finds them
> persisting still in our dreams, our vernacular and our art, for all
> the changes in the outward conditions of life.[3]

We ignore such myths at our peril: "Those who think that the world is more gentle and graceful than the primeval and predatory passions from which these myths sprang are . . . not aware of reality."[4] Rothko and the others investigating this early formulation were motivated by the horror of World War II. As it was to the dadaists and early surrealists just after World War I, war seemed proof that the "civilization" of society or the individual was just a thin veneer. The most noble and responsible act that an artist could perform was to demonstrate

160

that sad fact before illusions of progress in culture created more tragedy.

The techniques for discovering these ancient myths living deep within us were both analytic and mystical. Serious cross-cultural anthropology was combined with automatic writing, which sometimes was just unconscious doodling, other times a trancelike state cultivated to produce images spontaneously. Knox Martin, though younger and working later than the abstract expressionists, tells of his experiment to prove that no species enters the world with its mind a tabula rasa. He copied all the danger signs he could find from nature — for example, the hourglass shape from the back of a black widow spider — and made them into a design small enough to fit into the palm of his hand. Next he went to the aviary then at Macy's, whose birds surely never had any experience in the wild. Leaning on the glass and exposing the design, Martin was satisfied to see the birds shriek and fly around the case in terror.*

The second concept of the unconscious investigated by the abstract expressionists was Freudian: that the unconscious was empty but turbulent. Hydrostatic metaphors describe it: flows, blockages, escalating pressures, burstings, and overflows. The undifferentiating id surges in every direction; the superego erects dams against it. The ego "channels" this force to productive use. To be expressive the artist had to produce in his own handwriting this fluid "map of the unconscious." And the viewer had to become a graphologist. As Harold Rosenberg notes:

> Since the painter has become an actor, the spectator has to think in
> a vocabulary of action: its inception, duration, direction — psychic
> state, concentration and relaxation of the will, passivity, alert waiting.
> He must become a connoisseur of the gradations among the
> automatic, the spontaneous, the evoked.[5]

These were heavy burdens on artists such as Willem de Kooning, Jackson Pollock, and Franz Kline. "The new painting has broken down every distinction between art and life," Rosenberg said.[6] No artifact was part of painting, nothing for the artist to hide behind. Skill, training, taste, talent — all of these got in the way. The artist was a hero because a reckless, unguided psychoanalysis was necessary to open the self in this way. A painter could no more fake a painting

*I offer Martin's experiment not as scientific proof but as an example of how firmly artists hold their beliefs in mythic symbols.

than fool a graphologist about a change in personality on the basis of a faked change in handwriting. Zen calligraphy and existential philosophy both provided a context for this concept of the unconscious, as both exalted direct, irretrievable action.

Paint was set in motion — to extrapolate the gesture of the hand and magnify the impulse from the unconscious. Drips, runs, smears, and flicks were not accidents but existential intentions. Paintings needed to get bigger to house such energetic motion. Unlike the Myth Makers, the Action Painters (often the same individuals a few years later) did not base their style on haunting shapes; line, freed from its duty to describe shape, was the key element.

The third concept of the unconscious was the *no mind* of Zen: that the unconscious is like a perfectly polished mirror reflecting nature when the mirror is taken away. Zen and Zen calligraphy were discussed at the "club," that moveable feast of conversation and speculation where so many of the concepts of abstract expressionism were prepared. The doctrine of *no mind* states that each person can have an experience so deep that it is "unsupported" by words, thoughts, concepts, sights, sounds, tastes, and touches. Such an experience is enlightening because it demonstrates the relative, transient quality of the world of experience, allowing us to be more playful and creative with existence, and also because it connects the individual to the most basic of forces.

I do not know how much Milton Avery, Clyfford Still, Barnett Newman, or Mark Rothko knew about the history of Zen; the writings of Hui-nêng in ninth-century China may have escaped them. However, Hui-nêng's writing illustrates their point, and mine, so well that it is worth recounting the wonderful story of the battle of the poems. A poetry contest was underway to discover the next Chan Buddhist Patriarch. The heir apparent, the head monk, offered the following poem as proof of his enlightenment:

> *The body is the tree of perfect wisdom.*
> *The mind is the stand of a bright mirror.*
> *At all times diligently wipe it.*
> *Do not allow it to become dusty.*

The itinerant Hui-nêng, who was passing by, piped in and won the title:

> *Fundamentally perfect wisdom has no tree.*
> *Nor has the bright mirror any stand.*
> *Buddha nature is forever clear and pure.*
> *Where is there any dust?*[7]

162

Hui-nêng's poem ridicules the mind/body dichotomy of the previous poem and presents a powerful simile for emptiness, which is both a description of objective reality and a definition of the true mind. For Hui-nêng, a precise description of the nature of space was a picture of the self that, once grasped, was so powerful as to induce enlightenment, with all the enrichment of emotional life that term implies.

Robert Rosenblum places the work of this third period of abstract expressionism in the context of the sublime: "These infinite, glowing voids carry us beyond reason to the Sublime; we can only submit to them in an act of faith and let ourselves be absorbed into their radiant depths."[8] The sublime, Rosenblum states, is an invention of the European romantics, but it found an especially potent application in nineteenth-century American painting with the Hudson River School. The breathtaking expanse of these American vistas defied the formal integration of the individual in nature and mocked even the human imagination attempting to encompass the view.

Paintings by Newman, Still, and Rothko were vacant and formless, containing neither the shapes of the Myth Makers nor the lines of the Action Painters. Paint was to appear on the canvas as though by some natural process of osmosis, or decay, definitely not by the hand of the artist. Color — vaguely atmospheric color in space — was the powerful element of communication in these works.

The most creative of the abstract expressionists adopted each of these concepts of the unconscious in turn: the storehouse of archaic myths, the reservoir of surging, undifferentiated forces, the sublimely still and empty place underlying all perception. Each was soon considered inadequate and dropped. Since they are mutually exclusive and the formal implementation of each is so different, no synthesis of these three metaphors for the self was possible. Abstract expressionism did not last very long, and many of the artists involved were still young when they felt that they had completed their work and had no place to go.

The tragic flaw in all these theories is the golden nugget assumption: that by mining deeper, and discarding more and more debris, one could obtain a golden nugget of the self that was pure, authentic, and absolute. Such a golden nugget could not change, and it was assumed that an artist could only make one or two genuine paintings. Thus a brutal syllogism progressed: to be creative and authentic you had to repeat yourself. If authenticity equals repetition, it cannot equal creativity. In spite of all their passion for creativity and spontaneity,

these artists developed a philosophy of monotony. One cannot create ancient myths, or change one's essential handwriting daily, or improvise the enlightening sublime.

How different these static models of the self are from the one proposed by Robert Jay Lifton!

> In the course of studying young (and not so young) Chinese, Japanese, and Americans, I have become convinced that contemporary psychological patterns are creating a new kind of man — a "protean man."
>
> I found that many east Asians I interviewed had experienced an extraordinary number of beliefs and emotional involvements, each of which they could readily abandon in favor of another. Observations I have been able to make in America have also led me to the conviction that a very general process is taking place. I do not mean to suggest that everybody is becoming the same, or that a totally new "world-self" is taking shape. But I am convinced that a new psychological style is emerging everywhere.[9]

Lifton illustrates his new concept of the self with the story of a young Japanese man he interviewed in Japan over a period of time from 1960 to 1962. This man was from a middle-class family but was sent to live in the countryside during the war identified with the "common man." He was an ardent nationalist and hated Americans, but in high school, during a year in America, became so committed to American values that he converted to Christianity. Back in Japan, he reverted to earlier commitments to Marxism, almost becoming a leader of a revolutionary group; instead he decided to live the dissipated life of a playboy. Ultimately, he entered a large Japanese firm and became a company man.

Lifton continues:

> Two historical developments in particular have special importance for creating protean man.
>
> The first is the world-wide sense of what I have called *historical* (or *psychohistorical*) *dislocation*. We are experiencing a break in the sense of connection which men have long felt with the vital and nourishing symbols of their cultural tradition — symbols revolving around family, idea systems, religions, and the life cycle in general. Today we perceive these traditional symbols as irrelevant, burdensome, or inactivating, and yet we cannot avoid carrying them within us or having our self process profoundly affected by them.
>
> The second large historical tendency is the *flooding of imagery*

164

produced by the extraordinary flow of post-modern cultural influences over the mass communication networks, which readily cross local and national boundaries. Each individual is touched by everything, but at the same time he is overwhelmed by superficial messages and undigested cultural elements, by headlines and endless partial alternatives in every sphere of life. These alternatives, moreover, are universally and simultaneously shared — if not as courses of action, at least in the form of significant inner imagery.[10]

In Greek mythology Proteus was able to change his shape with relative ease — from wild boar to lion to dragon to fire to flood. But what he found difficult, and would not do unless seized and chained, was to commit himself to a single form, the form most his own, and carry on his function of prophecy. We can say the same of protean man, but we must keep in mind his possibilities as well as his difficulties.

The protagonist of *Little Big Man*, a book by Thomas Berger and later a film of that name, is another example of a protean man. Numerous times he changes back and forth from being a white man to an Indian, changing his dress, language, loyalties, and women. Usually these conversions are induced by threats to his life, but sometimes he seems to fall into lifestyles just because the possibilities exist. He is also at times a farmer, a gunslinger, a merchant, and a drunk. We do not feel that Little Big Man is playing at roles; he really becomes these different people. His body and body language change along with the changes of costume.

What is remarkable about this character is that we never feel that he is crazy or lacking an identity; rather, we see something strong in him that allows such flexibility, something strong that we have found in ourselves. I mentioned that I grew up in Japan, Okinawa, and Teheran, as well as Kansas City. But it was more complicated than that. In some places, I was a juvenile delinquent, others an athlete. At some postings, scholastics were in vogue, at others parties were. I decided to become a painter on the day I first saw the Jeu de Pomme in Paris when I was fourteen; it was like a sudden religious conversion. But before I could be an artist, I was a preppy at a snotty boarding school and a beatnik in New York. At times I felt intensely anxious. Who was it who could be all these different people? Yet, even when I was young, I also felt it was a kind of semantic problem, the definition of identity, rather than some lack in myself, and that my complex experience would always be a strength. I was omniatten-

RUDY RUCKER used to be a wild son of a bitch. An ex-hippie, he once wrote a comic strip inspired by underground comics such as *Zap*. The main character in this strip was a unicycle man with fervent anarchistic beliefs. From the few times that I met him personally, I would have to say that Rudy eats, smokes, drinks, and flirts aggressively and unabashedly. He is big, not quite fat, and has a Southerner's easy smile. I'm never quite sure whether Rudy's Rabelaisian qualities stem from the counterculture of the sixties or from a more old-fashioned, good ol' boy rabble-rousing tradition. He was once a singer in a rock and roll band, and at the same time drove a car with flames painted on the hood. His book *White Light* is a classic of the drug-trip genre — Mick Jagger meets the Dukes of Hazzard. (I learned about the car from a book jacket; he definitely wanted it known.) Rucker has a Ph.D in symbolic logic, was a disciple of the very great Kurt Gödel, yet spends a lot of his energy writing pulp science fiction and popularizations of established mathematics. Though he consistently wins prizes for these books, he brags that he does them only for the money.

Rucker does have a truly radical program, however. He wants to obliterate the distinction between philosophy, perception, and mathematics. The study of mathematics is the study of what can exist. Knowledge becomes a belief structure; one sees what is believed to be out there. "Postmodern mathematics" (Rucker's pregnant phrase) — the study of the equivocal, the uncertain, the incomplete, the infinite, and the amorphous — is extraordinarily different from the earlier mathematics on which our beliefs and perceptions are based. Remember what they told you in high school about mathematics being an exact science, and thus different from sociology or chemistry? Well, it isn't true. Our mathematical reality and our actual reality are not exact. We can know that inexactitude; we can also see it. It is our inevitable fate to evolve our consciousness to embrace this new reality.

Of course, I see Rucker as a deeply conservative man. Who needs drugs when there is mathematics? A natural-born college professor, Rucker has created popularizations that read like great university lectures, and he is a professor popular with the students, if not the administration. Rucker, a man with a large and happy family, has a view of the future as revealed in his science fiction that is filled with glory. Astounding things can be discovered when we really learn to use postmodern mathematics. Some sorry example of a hippie.

tive and willing to personally accept more. As I have grown older, my lifestyle has settled down a great deal, but the habit of new enthusiasms has persisted and is the basis of my creativity.

I once heard Buckminster Fuller lecture on a modern concept of the self. He talked about the old DC-3 airplanes. Over the years, so much information accumulated about the performance life of parts of these planes that parts could be routinely replaced just before they were due to fail. In this way, the planes — an identity, a number — could be kept flying even though none of the original plane was left. Since this is also true of the cells of the human body, clinging to a golden nugget concept of the self in a protean world is all the more absurd.

We can consider a protean sensibility not as a symptom of the dislocation of modern experience but rather as a healthy, creative adaptation to it. Being willing to identify, and to identify with, new possibilities is a capability to be admired and supported by our culture; the alternative is to lead lives with a very short productive period or to overspecialize to the point of irrelevance. The danger of a protean philosophy is that it might laud superficiality, but given the world we live in, such a risk must be taken by those in our culture who define our values.

> Leaning against the sun and the moon and carrying the universe
> under his arm, the sage blends everything into a harmonious whole.
> He is unmindful of the confusion and the gloom, and equalizes the
> humble and the honorable. The multitude strive and toil; the sage
> is primitive and without knowledge. He comprehends ten thousand
> years as one thought, whole and simple. All things are what they
> are, and are thus brought together.[11]

There are wormholes out there, and we as consciousnesses go through them to the degree we accept our protean nature. So then, young scientist, listen to Exebar! The scientist who discovers the next level of reality will be one who leans against the sun and the moon, who lives a protean life and sees with a protean eye. Such a person sees the true space of subjective experience, faces up to the new aesthetics and the new emotions that are thereby engendered, and then takes these as a guide to objective reality. Abandon thy slide rule . . . and take in a few shows.

Plate 2.

Note: Plate 1 appears on page 30.

Untitled, 1975, acrylic on canvas, 56" × 140", collection of the artist.

Plate 3. Untitled, 1976, acrylic on canvas, 56″ × 70″,
 collection of AT&T.

Plate 4. Untitled #7, 1976, acrylic on canvas, 56″ × 70″,
 collection of the artist.

Plate 5. Untitled #4, 1978, acrylic on canvas, 56″ × 70″,
 collection of Max K. Robbin.

Plate 6. Untitled #10, 1978, acrylic on canvas, 56″ × 70″, 171
 collection of the artist.

Plate 7. Untitled #16, 1978, acrylic on canvas, 56″ × 70″,
collection of the artist.

Plate 8. Untitled, 1978, acrylic on canvas, 56″ × 70″,
collection of Rogier de La Bourde.

Plate 9. Untitled #19, 1978, acrylic on canvas, 56″ × 70″,
 private collection, New York.

Plate 10. Untitled #16, 1979, acrylic on canvas, 56″ × 70″,
 collection of Judy Wells Martin. 173

Plate 11.

174

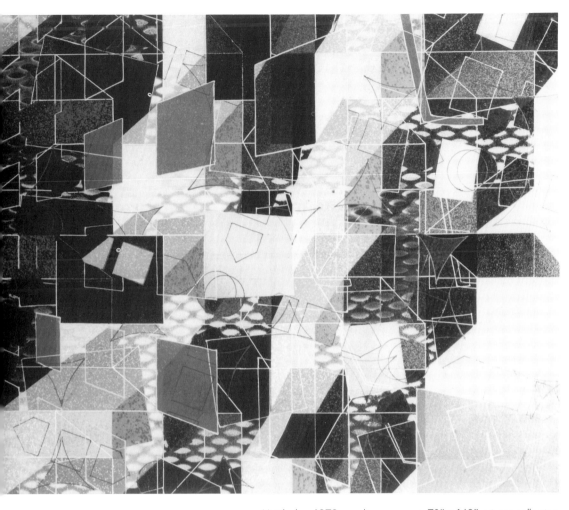

Untitled, c. 1979, acrylic on canvas, 70" × 140", private collection.

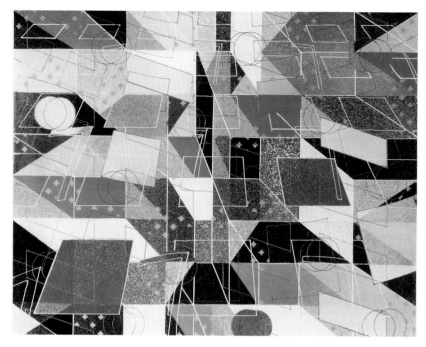

Plate 12. Untitled #16, 1979, acrylic on canvas, 56″ × 70″,
private collection.

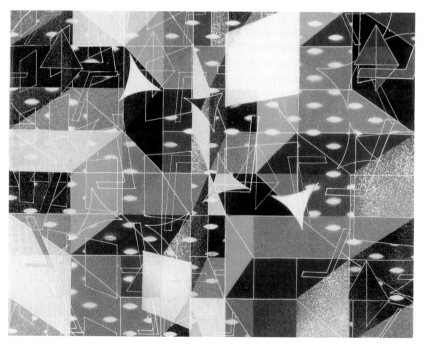

Plate 13. Untitled #1, 1980, acrylic on canvas, 56″ × 70″,
private collection.

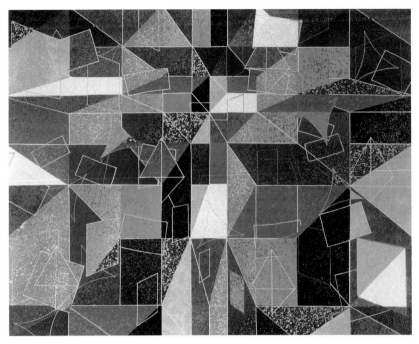

Plate 14. Untitled #8, 1980, acrylic on canvas, 56″ × 70″,
collection of the artist.

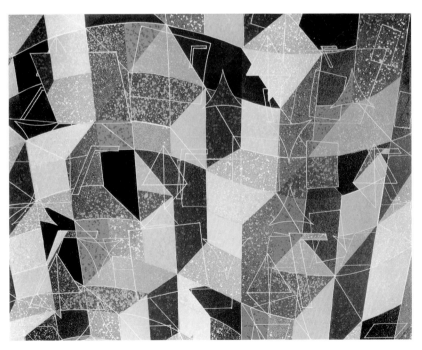

Plate 15. Untitled #18, 1980, acrylic on canvas, 56″ × 70″, 177
collection of Max K. Robbin.

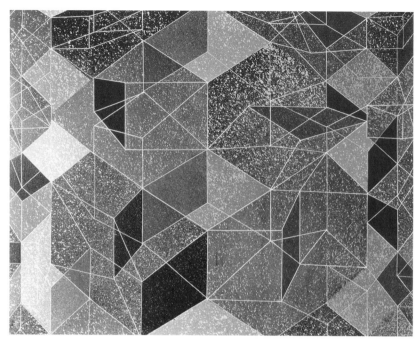

Plate 16.

Untitled #8, 1981, acrylic on canvas, 56" × 70",
collection of the artist.

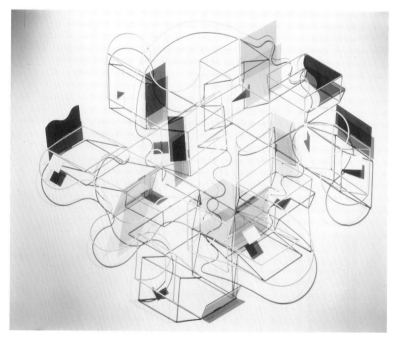

Plate 17.

Untitled #1, 1986, welded steel, plastic, and colored light,
70" × 70" × 15", collection of the artist.

Appendix 1

Vincent Van Gogh's Letter

My dear Theo, Arles, 8 September 1888

Thank you a thousand times for your kind letter and the 300 francs it contained; after some worrying weeks I have just had one of the very best. And just as the worries do not come singly, neither do the joys. For just because I am always bowed under this difficulty of paying my landlord, I made up my mind to take it gaily. I swore at the said landlord, who after all isn't a bad fellow, and told him that to revenge myself for paying him so much money for nothing, I would paint the whole of his rotten joint so as to repay myself. Then to the great joy of the landlord, of the postman whom I had already painted, of the visiting night prowlers and of myself, for three nights running I sat up to paint and went to bed during the day. I often think that the night is more alive and more richly colored than the day.

Now, as for getting back the money I have paid to the landlord by means of my painting, I do not dwell on that, for the picture is one of the ugliest I have done. It is the equivalent, though different, of the "Potato Eaters."

I have tried to express the terrible passions of humanity by means of red and green.

The room is blood red and dark yellow with a green billiard table in the middle; there are four citron-yellow lamps with a glow of orange and green. Everywhere there is a clash and contrast of the most disparate reds and greens in the figures of little sleeping hooligans, in the empty, dreary room, in violet and blue. The blood red and the yellow-green of the billiard table, for instance, contrast with the soft tender Louis-XV green of the counter, on which there is a pink nosegay. The white coat of the landlord, awake in a corner of that furnace, turns citron-yellow or pale luminous green.

I am making a drawing of it with the tones in watercolor to send to you tomorrow to give you some idea of it.

I wrote this week to Gauguin and Bernard, but I did not talk about anything but pictures, just so as not to quarrel when there is probably nothing to quarrel about. But whether Gauguin comes or not, if I were to get some furniture, henceforth I should have, whether in a good spot or a bad one is another matter, a pied-à-terre, a home of my own, which frees the mind from the dismal feeling of being a homeless wanderer. That is nothing when you are an adventurer of twenty, but it is bad when you have turned thirty-five.

Today I read something about the suicide of Mr. Bing Levy in the Intransigent. It can't be the Levy who is Bing's manager, can it? I think it must be someone else.

I am greatly pleased that Pissarro thought something of the "Young Girl." Has Pissarro said anything about the "Sower"? Afterward, when I have carried these experiments even further, the "Sower" will still be the first attempt in that style. The "Night Café" carries on the style of the "Sower," as do the head of the old peasant and of the poet also, if I manage to do this latter picture.

It is color not locally true from the point of view of the delusive realist, but color

suggesting some emotion of an ardent temperament.

When Paul Mantz saw at the exhibition the violent and inspired sketch by Delacroix that we saw at the Champs Elysées — the "Bark of Christ" — he turned away from it, exclaiming, "I did not know that one could be so terrible with a little blue and green."

Hokusai wrings the same cry from you, but he does it by his line, his drawing, just as you say in your letter — "the waves are claws and the ship is caught in them, you feel it."

Well, if you make the color exact or the drawing exact, it won't give you sensations like that.

Anyhow, very soon, tomorrow or the day after, I'll write you again about this and send you the sketch of the "Night Café."

Tasset's parcel has arrived. I'll write tomorrow on this question of the coarse-grain paints. Millet is coming to see you and pay his respects to you one of these days, he writes me that he is coming back.

Thank you again for the money you sent. If I went first to look for another place, would it not very likely mean fresh expenses, equal at least to the cost of moving? And then should I find anything better all at once? I am so very glad to be able to furnish my house, and it can't but help me on. Many thanks then, and a good handshake, till tomorrow.

<div align="right">Ever yours,
Vincent</div>

Appendix 2

Hardware and Software Notes

I use an IBM-AT with X-tar's Polygone Graphics card. This system can provide real-time rotations of figures of about five hundred lines, with dozens of filled planes. I use a United Innovations flatbed plotter. I program in Pascal, and like Microsoft's Pascal 4.0 compiler best.

The programs have been prepared for general release by Kurt Baumann of Artware+Software, using Microsoft's Quick Pascal. This compiler has procedures for writing generic code that will self-adjust to all the common hardware configurations, as well as procedures for double-buffering the image for smoothness (computing a second image while the first is still being displayed). Will Johnson of Fast Forward Technologies converted the programs to run on Macintosh computers, using Symantec's THINK-pascal. Compile-ready source code for Hyper is provided for IBM or Mac on their respective disks.

When you receive your disk, first put the disk into your Drive A, then read and print out the manual using your word-processing program. IBM users with a printer can type "copy a:\manual prn"; Mac users with a printer can click on the Manual icon, and then select "Print" from the file menu.

180

Notes

Introduction

1. On the importance of science for both Duchamp and Kupka, see L. D. Henderson, *Duchamp in Context: Science and Technology in the "Large Glass" and Related Early Works* (forthcoming, Princeton University Press). For Duchamp's exploration of four-dimensional and non-Euclidean geometries, see Henderson, *The Fourth Dimension and Non-Euclidean Geometry in Modern Art* (Princeton, N.J.: Princeton University Press, 1983), and Craig E. Adcock, *Marcel Duchamp's Notes from the "Large Glass": An N-Dimensional Analysis* (Ann Arbor, Mich.: UMI Research Press, 1983).

2. On this subject, see L. D. Henderson, "X Rays and the Quest for Invisible Reality in the Art of Kupka, Duchamp, and the Cubists," *Art Journal* 47 (Winter 1988): 323–24.

3. Stein letter to Mabel Dodge, Mabel Dodge Luhan Archive, Yale University.

4. Duchamp, as quoted in James Johnson Sweeney, "Eleven Europeans in America," Museum of Modern Art *Bulletin* 13 (1946): 20; reprinted in *Salt Seller: The Writings of Marcel Duchamp*, eds. Michel Sanouillet and Elmer Peterson (New York: Oxford University Press, 1973), 125.

5. *Writings of Marcel Duchamp*, 71.

6. Ibid., 90. For Poincaré's similar discussion, see Henderson, *Fourth Dimension*, 84–85.

7. On the popularization of relativity theory and the artistic response to it, see Henderson, *Fourth Dimension*, 318–38 and appendix A.

8. *Writings of Marcel Duchamp*, 49.

9. M. V. Matyushin, "Of the Book by Gleizes and Metzinger, *Du Cubisme*," *Union of Youth*, no. 3 (March 1913): 25; in Henderson, *Fourth Dimension*, appendix C.

1. Einstein's Cave

1. Jules-Henri Poincaré, *Science and Hypothesis* (New York: Dover Publications, 1952), 58–70.

2. Henderson, *Fourth Dimension*, 339.

3. Poincaré, *Science and Hypothesis*, 51.

4. H.S.M. Coxeter, *Regular Polytopes* (New York: Dover Publications, 1973), 119.

5. Heinz Von Foerster and staff, *B. C. L. Reports*, Biological Computer Laboratory, Department of Electrical Engineering, University of Illinois, Urbana, no. 712, pp. 201–215, and no. 722, pp. 223–236.

2. Emotional Equations: Space in Mathematics and Art

1. Plato, *The Republic*, line 603, trans. John Llewelyn Davies and David James Vaughan (London: Macmillan and Company, 1891).

2. Charles W. Misner, Kip S. Thorne, and John A. Wheeler, *Gravitation* (New York: W. H. Freeman, 1970), 1202.

3. Chinese Boxes and Shadows from Heaven

1. Tony Robbin, "Spatial Complexity in New York Painting," *Artscribe*, Fall 1977, 19.

2. John Dee, "The Imagination of Space," *Aspects*, no. 28 (Autumn 1984), n.p.

3. Jules-Henri Poincaré (from *The Foundations of Science*) as quoted by John Dee in "Space Complex," his exhibition catalog for the Third Eye Center (Glasgow) touring exhibition of the same name.

4. Poincaré, *Science and Hypothesis*, 50.

5. Albert Einstein, *Relativity* (New York: Crown Publishers, 1961), 138.

6. Jonathan Schwartz, a philosopher of science and a student of relativity theory, was my mathematics tutor during the period I was working on this idea, and his help in understanding and articulating it was very valuable.

4. Patterns in the Ether

1. Robert E. Ornstein, *The Psychology of Consciousness*, 2d ed. (New York: Harcourt Brace Jovanovich, 1977), 24ff.

2. Ibid.

5. Curvature: Lobofour and Nonclid

1. Albert Einstein and Leopold Infeld, *The Evolution of Physics* (New York: Simon and Schuster, 1938), 217.

2. Misner, Thorne, and Wheeler, *Gravitation*, 13ff.

3. Hans Reichenbach, *The Philosophy of Space and Time* (New York: Dover Publications, 1952), 55.

4. William P. Thurston and Jeffrey Weeks, "Mathematics of Three-Dimensional Manifolds," *Scientific American* 251, no. 1 (July 1984).

5. Thomas Banchoff, *Beyond the Third Dimension*, 126.

6. Time *in* Space: Three Enigmas of Space

1. Larry Abbott, "The Mystery of the Cosmological Constant," *Scientific American* 256, no. 5 (May 1988), 106.

2. Ibid., 112.

3. David Layzer, "The Arrow of Time," *Scientific American* 233, no. 6 (December 1975), 56.

7. Exebar Speaks!

1. Stuart Cary Welch, *A King's Book of Kings* (Boston: Bulfinch Press, 1972), 25.

2. Ibid., 30.

3. Rothko quoted in Irving Sandler, *The Triumph of American Painting* (New York: Praeger, 1970), 63.

4. Ibid., 65.

5. Harold Rosenberg, "The American Action Painters," in Henry Geldzahler, *New York Painting and Sculpture: 1940–1970* (New York: E. P. Dutton and Company, 1970), 344.

6. Ibid., 343.

7. Hui-nêng, *The Platform Scripture*, trans. W. T. Chan (New York: St. John's University Press, 1963), 39–41.

8. Robert Rosenblum, "The Abstract Sublime," in Geldzahler, *New York Painting and Sculpture*, 353.

9. Robert Jay Lifton, "Protean Man," *Alumni Magazine* (New Haven: Yale Alumni Publications) 27, no. 4 (January 1969), 14.

10. Ibid., 15–16.

11. Chuang Tzu, *Basic Writings*, trans. Burton Watson (New York: Columbia University Press, 1964), 42.

Glossary

Algorithm. A system for accomplishing a task, usually a mathematical task. The sequence of steps of long division is an algorithm; a computer program is a number of algorithms strung together.

Anthropic principle. Explains the existence of cosmological facts by noting that only certain conditions could have evolved life in the universe.

Atmospheric perspective. A color system in painting for depicting the illusion of space whereby objects farther away are presented as less intense and paler in hue than those closer to the viewer. *See also* Perspective.

Bell inequality experiments. Present the paradox of quantum reality: at small scales, objects can be in several states of being at the same time until they are observed, and, moreover, have a cause-and-effect structure that is oblivious to time. Also known as *delayed-choice experiments.*

Big Bang. The widely accepted theory that the universe (all matter, all energy, all space) began at once in an infinitely small area and has been expanding for the approximately ten billion years since then.

Black hole. A star that has collapsed under its own gravity, becoming so dense that not even light can escape from its surface.

Coordinate system (CS). A geometric grid attached to a moving body. For example, a rocket ship traveling in outer space has its own coordinate system; all the astronauts agree on what up and down mean even though they are far from earth. This coordinate system extends from the ship to include the origin of all information under consideration, and if the rocket ship is moving near the speed of light its coordinate system defines dimensions and times differently than the stationary viewer would.

Cosmological constant. A number equal to the amount of energy contained in empty space (which, according to modern physical theory, is not zero). This number also defines the degree of curvature in the universe.

Delayed-choice experiments. *See* Bell inequality experiments.

Dodecahedron. One of the five platonic solids, so named because all the faces of the solid are identical regular shapes. Twelve regular pentagons of the same size make up the dodecahedron.

Dual. The pattern of the centers. For example, the dual of a pattern of squares is also a pattern of squares, while the dual of a pattern of hexagons is a pattern of triangles. In three dimensions, the dual of the cube is an octahedron, because lines joining the centers of the six square faces form an octahedron. An icosahedron and a dodecahedron are duals of each other.
Dual methods construct patterns by first constructing the pattern of the dual and then converting to the — usually more complicated — pattern desired.

Entropy. A term in physics defining the imperfection in the transfer from one physical state to another. For example, when wood is burned to boil water some of the potential heat energy in the wood is not transferred to the water but instead heats the air, ultimately radiates into outer space, and is lost forever to productive use. The universe as a whole is thought to have originated with infinite heat condensed into an infinitely small space; since then it has been losing heat and concentration and gaining entropy.

Field. In physics, a pattern of energy in space that can be described by geometry. For example, the pattern of metal filings formed on a piece of paper by a strong magnet beneath the paper is a field. In painting, the term refers to both realistic and abstract works in which there is visual activity spread evenly across a canvas, and where the flat surface of the canvas is also emphasized.

Flatland. The imaginary setting of Edwin Abbott Abbott's book *Flatland: A Romance of Many Dimensions*, which describes how three-dimensional objects would appear to two-dimensional creatures (*Flatlanders*), or how three-dimensional processes could be performed in two dimensions. Abbott's book is also an imaginative social and feminist critique of the strata of English society.

Fourfield. Refers to the pattern of space in four Euclidean geometric dimensions.

Fourth dimension. Another spatial dimension similar in kind to the other three. In geometry, the fourth dimension is represented by an axis line that begins at the origin (the center of a grid) and continues indefinitely. This fourth axis is simultaneously perpendicular to each of the other three axis lines, and points away from each of these, never intersecting any of them.

Fractal geometry. A new geometry of fractional dimensions. For example, a line might have a dimension between the first and the second if it meanders to such a degree, and in a consistent way, that it almost covers a plane. Fractal patterns are self-similar, which means that no matter how closely the figure is examined it looks the same (on each triangle are triangles, on each of those are triangles, etc.).

Frame of reference. The coordinate system in which observations are made is the frame of reference for that observer.

Golden zonohedra. First studied by Kepler, these semiregular geometric solids all have the same rhombic face, the diagonals of which are in the golden ratio 1:1.61803. . . . The golden ratio is also the ratio of the volumes of the constituent fat and thin rhombic cells. The golden ratio is based on an irrational number $\frac{1+\sqrt{5}}{2}$ and it has the peculiar property that if the numbers are subtracted, rather than divided, the remainder and the original, smaller number are in the golden ratio.

Hypercube. A four-dimensional cube. It has eight cube cells, twenty-four square faces, sixteen vertices (each made up of four mutually perpendicular lines), and thirty-two edges all the same length.

Icosahedron. The platonic solid made from twenty equilateral triangles.

Impossible figures. Geometric figures that cannot be resolved into a single consistent spatial reading.

184

Inflationary model of cosmology. The proposal that during its early history, the universe underwent an enormous acceleration in its expansion. Because the hypothesis seems to explain a number of perplexing and otherwise unrelated problems with the standard Big Bang theory, it is gaining acceptance among scientists.

Isometric. A mathematical operation, such as projection or rotation, that leaves a geometric figure unchanged in size or shape is said to be an isometric operation.

Metric. The way distance is computed from starting and ending locations is called a metric. Different curvatures require different metrics.

Necker-reversing figures. Geometric figures of orthographic projections that switch between two consistent spatial readings. Named after the Swiss philosopher who first studied them.

Non-Euclidean geometry. Any geometry with an alternate postulate about parallel lines. During the nineteenth century, mathematicians discovered that Euclid's postulate that only one line is parallel to a given line (meaning also that parallel lines never intersect) is not essential to a consistent geometry, and that alternate geometries could be developed in which parallel lines intersect twice, or in which more than one line can be parallel to a given line at a point, and so on.

Orthogonal. Pertaining to perpendicular lines; a projection that is at right angles to the figure and not skewed is orthogonal.

Parallax. The apparent displacement or change in appearance of an object due to a change in position of the observer.

Particle pair. In order to maintain the conservation laws of physics, when energy is converted into particles it is converted into pairs of particles with opposite characteristics.

Penrose tessellation. A pattern named for Roger Penrose that covers a surface with just two shapes. Although the pattern has considerable order, it never quite repeats.

Perspective. A system for creating the illusion of space in a painting, whereby objects farther away are systematically shown to be smaller. Railroad tracks that come together at a point are drawn in perspective. Cameras make perspective pictures, which means that the lens of the eye also makes perspective pictures on the retina. However, perspective did not occur systematically in painting until projective geometry was invented. *See also* Atmospheric perspective.

Projection. A mathematical operation that transfers geometric figures from one space to another, usually lower-dimensional, space. Sunlight projects shadows from a vase onto the floor.

Projective geometry. A mathematical generalization of perspective.

Quantum. Matter and energy exist in the form of indivisible packets called quanta, rather than in a continuously divisible form. These quanta behave both like a particle and like a wave, and have an indefinite existence until they interact with a known system. Space itself may well have quantum properties, and be foamy rather than smoothly, infinitely divisible.

Quasicrystal geometry. Generally, the three-dimensional version of Penrose tessellation, in which just two shapes of blocks fill all of space in a nonrepeating pattern.

Real time. When computers respond to users' instructions (move a cube to the left, for example) so fast that the user has the illusion of manipulating objects directly, then the computers are said to be real-time computers. Since each picture or geometric object can require the recomputation of many points, and since about fifteen complete images each second are required for the real-time effect, only very fast computers can provide it.

Rhombohedron. A cube skewed so that all six faces are identical rhombs. A *rhomb* is a diamond shape of which all four sides are the same length.

720-degree property. A property of space exemplified by a Möbius strip — a twisted and joined piece of material — in which a 360-degree circuit does not return to the starting point but a 720-degree circuit does.

Slicing. A mathematical operation that reduces an object to a series of lower-dimensional objects by taking small, parallel sections of it. A slicing of a cube might result in a series of squares or, if the cube were turned edge-forward rather than face-forward, a series of rectangles. A hypercube could be sliced by a hyperplane to produce a series of cubes or, if turned, a series of hexagonal prisms, or a more complicated series of tetrahedra, octahedra, and other figures.

Spacelike. When two events occur separated by such a distance and at such times that light signals could not pass between them (to trigger or signal the events) then they have a spacelike separation between them.

Space-time. One application of four-dimensional geometry is space-time physics, where three dimensions of space and one of time are plotted on a four-dimensional grid. Only four-dimensional distances are consistent, even as their parts are deformed by relativistic effects.

Spline. A mathematical technique for generating a smooth curve between various points in space.

Superluminal. Faster than the speed of light. Although special relativity excludes objects from attaining speeds greater than the speed of light, as that would entail infinite force on infinite mass in an infinitesimal volume, recently there has been speculation that some objects might be created that travel faster than the speed of light, or that some sort of information might be passed at such speeds.

Tessellate. To tile; to cover a surface with units of the same shape, or a limited number of shapes. Each shape is said to be a tile of the pattern.

Theory of relativity. The special theory of relativity, invented by Einstein in the early years of this century, states that since the speed of light is the same for all viewers regardless of their state of uniform motion, then time must run at different rates and space must contract for different viewers. The general theory of relativity states that, since acceleration and gravity both affect matter the same way, both can be described by depicting space as curved. Both the special theory and the general theory have been confirmed by numerous experiments conducted over the last seventy years.

186

Three-space. Regular three-dimensional space with Euclidean coordinates. Four-space is also a contraction for four-dimensional space, considered to be Euclidean unless otherwise identified.

Topology. The study of mathematical surfaces (called *manifolds*), which could be any dimension, concentrating on the properties on the surfaces rather than on any specific shape that the surface may take. A sphere and a cube are the same to a topologist, and both are equally different from a pretzel because a pretzel has three holes and cubes and spheres have none.

Torus. A geometric object shaped like a doughnut or an inner tube. In mathematics a torus can have more than one hole, like the traditional shape of a pretzel.

Triacontahedron. A thirty-faced geometric solid. The triacontahedron discussed in the book is one of the golden zonohedra; it has thirty identical rhombic faces, with the diagonals of each in the golden ratio. This ball-shaped object can be built from ten fat and ten thin quasicrystal blocks, or by superimposing a dodecahedron and an icosahedron and connecting all the vertices together, which means that, though the figure is made up of all the same shapes, the vertices are not all the same distance from the center.

Twistor theory. Penrose's invention of a mathematical device to integrate quantum theory and relativity theory. A twistor is made up of both a real part (ordinary numbers) and an imaginary part (numbers based on $\sqrt{-1}$).

Unit cell. The tiles of a multidimensional tessellation. When laying a brick wall with all the same size bricks, any brick is a unit cell; if half-bricks are also used, then a brick and a half-brick are both unit cells of the pattern.

Vacuum energy density. Although it would seem that empty space can have no energy stored in it, physics has shown this not to be true. The amount of energy per unit of volume of empty space is its vacuum energy density.

Virtual particles. The potential for the creation of particles in empty space has led to the notion that all possible particles already exist in empty space in a virtual state, a state considered to be characterized by instantaneous creation and simultaneous destruction of the particles.

Wormhole. In physics, a term used to describe gaps in space. Due to quantum effects, particles can sometimes appear in a different location or pass through a barrier they otherwise could not cross; these passages are called tunnels or, more commonly, wormholes.

Bibliography

Abbott, Edwin A. *Flatland: A Romance of Many Dimensions.* New York: Barnes and Noble Books, 1963.

Abbott, Larry. "The Mystery of the Cosmological Constant." *Scientific American,* 256, no. 5 (May 1988).

————. "Baby Universes and Making the Cosmological Constant Zero." *Nature,* 336 (22–29 December 1988).

Abbott, L. F. "A Mechanism for Reducing the Value of the Cosmological Constant." *Physics Letters,* 150B, no. 6 (24 January 1985).

Armstrong, William F., and Robert P. Burton. "Perception Clues for *n* Dimensions." *Computer Graphics World,* March 1985.

Baer, Steve. "The Discovery of Space Frames with Fivefold Symmetry." In *Five Fold Symmetry,* edited by Istvan Hargittai. Teaneck, N.J.: World Scientific Publishing Company, 1991.

————. "Structural System." U.S. Patent Office, no. 3,722,153 (27 March 1973).

Banchoff, Thomas. *Beyond the Third Dimension.* New York: W. H. Freeman, 1990.

————. *Hypersphere.* Film distributed by Thomas Banchoff.

Banchoff, Thomas, and Charles Strauss. *The Hypercube, Projections and Slicings.* Film distributed by International Film Bureau.

Banchoff, Thomas, and John Wermer. *Linear Algebra Through Geometry.* New York: Springer-Verlag, 1983.

Brisson, David W., ed. *Hypergraphics.* American Association for the Advancement of Science Selected Symposium, no. 24. Boulder, Colo.: Westview Press, 1978.

Bronowski, J. *The Ascent of Man.* Boston: Little, Brown and Company, 1973.

Capra, Fritjof. *The Tao of Physics.* New York: Bantam Books, 1977.

Chuang Tzu, *Basic Writings.* Translated by Burton Watson. New York: Columbia University Press, 1964.

Coxeter, H.S.M. *Regular Polytopes.* New York: Dover Publications, 1973.

de Bruijn, N. "Algebraic Theory of Penrose's Non-Periodic Tilings of the Plane." *Ned. Akad. Weten Proc. Ser. A,* 1981.

Dee, John. "The Imagination of Space." *Aspects,* no. 28 (Autumn 1984).

————. "Space Complex." Catalog essay. Glasgow: Third Eye Center, 1984.

Dewdney, A. K. *Planiverse.* New York: Poseidon Press, 1984.

Einstein, Albert. *Relativity.* New York: Crown Publishers, 1961.

Einstein, Albert, and Leopold Infeld. *The Evolution of Physics.* New York: Simon and Schuster, 1938.

Einstein, Albert, with A. Lorentz, H. Minkowski, and H. Weyl. *The Principle of Relativity.* New York: Dover Publications, 1952.

Elser, Viet, and N.J.A. Sloane. "A Highly Symmetric Four-Dimensional Quasicrystal." *Journal of Physics A,* 1987.

Ernesto, C., S. Lindgren, and Steve Slaby. *Four-Dimensional Descriptive Geometry.* New York: McGraw-Hill Company, 1968.

d'Espagnat, Bernard. "The Concepts of Influences and Attributes as Seen in Connection with Bell's Theorem." *Foundations of Physics II* 205 (April 1985).

———. "The Quantum Theory and Reality." *Scientific American* 241, no. 5 (November 1979).

Freedman, Michael Hartley. "The Topology of Four-Dimensional Manifolds." *Journal of Differential Geometry* 17 (1982): 357–453.

Gamow, George. *One, Two, Three . . . Infinity.* New York: Bantam Books, 1947.

Gardner, Marvin. "Extraordinary Nonperiodic Tiling. . . ." *Scientific American* 236 (January 1977): 100.

Geldzahler, Henry. *New York Painting and Sculpture: 1940–1970.* New York: E. P. Dutton and Co., 1970.

Gleick, James. *Chaos: Making of a New Science.* New York: Viking, 1987.

Gombrich, E. H. *Art and Illusion.* New York: Pantheon Books, 1960.

———. *The Sense of Order.* Ithaca, N.Y.: Cornell University Press, 1979.

Greenberg, Marvin Jay. *Euclidean and Non-Euclidean Geometries: Development and History.* New York: W. H. Freeman, 1972.

Gregory, R. L. *Eye and Brain.* New York: McGraw-Hill Paperbacks, 1978.

Gunn, Charlie. *Not Knot.* Video distributed by Geometry Supercomputer Project, Minneapolis.

Hawking, Stephen W. *A Brief History of Time.* New York: Bantam Books, 1988.

Heelan, Patrick A. *Space Perception and the Philosophy of Science.* Berkeley: University of California Press, 1983.

Heiserman, David L. *Experiments in Four Dimensions.* Blue Ridge Summit, Penn.: Tab Books, 1983.

Henderson, Linda Dalrymple. *The Fourth Dimension and Non-Euclidean Geometry in Modern Art.* Princeton, N.J.: Princeton University Press, 1983.

Hinton, Charles H. *Speculations on the Fourth Dimension.* Edited by Rudolf v. B. Rucker. New York: Dover Publications, 1980.

Hui-nêng. *The Platform Scripture.* Translated by W. T. Chan. New York: St. John's University Press, 1963.

Ivins, William M., Jr. *Art and Geometry: A Study in Space Intuitions.* New York: Dover Publications, 1964.

Kajikawa, Yasushi. "Growing Icosahedra." *Nikkei Science,* September 1990.

Kappraff, Jay. *Connections: The Geometric Bridge Between Art and Science.* New York: McGraw-Hill, 1991.

Kaufman, William J. III. *The Cosmic Frontiers of General Relativity.* Boston: Little, Brown and Company, 1977.

Kuhn, Thomas S. *The Structure of Scientific Revolutions.* Chicago: University of Chicago Press, 1970.

Lalvani, Haresh. "Building Structures Based on Polygonal Members and Icosahedral Symmetry." U.S. Patent Office, no. 4,723,382 (9 February 1988).

————. "Non Periodic Space Filling with Golden Polyhedra." Proceedings of the First International Conference on Light Weight Structures, Sydney, Australia, August 1986, LSA 86, vol. 1, 202–11.

————. "Non Periodic Space Structures," *Space Structures* 2, no. 2 (1986–87): 93–108.

Layzer, David. "The Arrow of Time." *Scientific American* 233, no. 6 (December 1975).

Levine, Dov, and Paul Steinhardt. "Quasicrystals, I." *Physical Review B*, July 1986.

Lifton, Robert Jay. "Protean Man." *Alumni Magazine* (New Haven: Yale Alumni Publications) 27, no. 4 (January 1969).

Manning, Henry Parker. *Geometry of Four Dimensions.* New York: Dover Publications, 1956.

Misner, Charles W., Kip S. Thorne, and John A. Wheeler. *Gravitation.* New York: W. H. Freeman, 1970.

Miyazaki, Koji. *An Adventure in Multidimensional Space.* New York: Wiley, 1986.

Miyazaki, Koji, and I. Takada. "Uniform Ant-Hills in the World of Isozonohedra." *Structural Topology* 4 (1980).

Morris, Richard. *Time's Arrow: Scientific Attitudes Towards Time.* New York: Simon and Schuster, 1985.

Nelson, David. "Quasicrystals." *Scientific American* 255, no. 2 (August 1986).

Nöll, A. Michael. "Computer Animation and the Fourth Dimension." *Afips-Conference Proceedings*, vol. 13. Washington, D.C.: Thompson Book Company, 1968.

————. "Displaying n-Dimensional Hyperobjects by Computer." *Communications of the ACM* 10,469 (1967). Reprinted in David W. Brisson, ed., *Hypergraphics* (Boulder, Colo.: Westview Press, 1978).

Ornstein, Robert E. *The Psychology of Consciousness.* 2d ed. New York: Harcourt Brace Jovanovich, 1977.

Penrose, Roger. *The Emperor's New Mind.* New York: Oxford University Press, 1989.

Perreault, John. "Issues in Pattern Painting." *Artforum*, November 1977.

Peterson, Ivars. "The Five Fold Way for Crystals." *Science News* 127, no. 12 (23 March 1985): 188–89.

Peterson, Ivars. *Islands of Truth, A Mathematical Mystery Cruise.* New York: W. H. Freeman and Company, 1990.

————. *The Mathematical Tourist.* New York: W. H. Freeman and Company, 1988.

————. "Recipes for Artificial Realities." *Science News* 138, no. 12 (21 March 1990): 321–36.

Pickvance, Ronald. *Van Gogh in Arles.* New York: The Metropolitan Museum of Art/Harry N. Abrams, 1984.

Poincaré, Jules-Henri. *Science and Hypothesis.* New York: Dover Publications, 1952.

Reichenbach, Hans. *The Philosophy of Space and Time.* New York: Dover Publications, 1958.

Rigby, J. F. "Compound Tilings and Perfect Colorings." *Leonardo* 24, no. 1 (1991).

190

Robbin, Tony. "Chuangtze." *Main Currents* 23, no. 1 (September 1974).

———. "4D Geometry and Visual Paradox." *Tracts,* Winter 1976.

———. "4D Tessellations." *Criss-Cross Art Communications* (Boulder, Colorado), no. 7 (1979).

———. "Images: Two Ocean Projects at MOMA." *Arts Magazine,* November 1969.

———. "Painting and Physics: Modeling Artistic and Scientific Experience in Four Spatial Dimensions." *Leonardo* 17, no. 4 (1984).

———. "Peter Hutchinson's Ecological Art." *Art International,* February 1970.

———. "A Protean Sensibility." *Arts Magazine,* May 1971.

———. "Quasicrystal Architecture." *Symmetry of Structure Proceedings.* Budapest: Hungarian Academy of Science, 1989. Reprinted in *Leonardo* 23, no. 1 (Spring 1990).

———. "Smithson's Non-Site Sights." *ARTnews,* February 1969.

———. "Spatial Complexity in New York Painting." *Artscribe,* Fall 1977.

———. "Statement." *Artforum,* September 1975.

Rucker, Rudy. *Geometry, Relativity and the Fourth Dimension.* New York: Dover Publications, 1977.

———. *Mind Tools.* Boston: Houghton Mifflin Company, 1987.

———. *Towards a Geometry of Higher Reality.* Boston: Houghton Mifflin Company, 1984.

Sandler, Irving. *The Triumph of American Painting.* New York: Praeger, 1970.

Socolar, Joshua, and Paul Steinhardt. "Quasicrystals, II." *Physical Review B,* July 1986.

Socolar, Joshua, Paul Steinhardt, and Dov Levine. "Quasicrystals . . . " *Physical Review B Rapid Communications,* October 1985.

Sommerville, D.M.Y. *An Introduction to the Geometry of N Dimensions.* New York: Dover Publications, 1958.

Steinberg, Leo. *Other Criteria: Confrontations with Twentieth-Century Art.* New York: Oxford University Press, 1972.

Steinhardt, Paul. "Quasicrystals." *American Scientist* 74 (November–December 1986): 586–97.

Tauber, Gerald, ed. *Albert Einstein's Theory of General Relativity.* New York: Crown Publishers, 1979.

Thomsen, Dietrick E. "The New Inflationary Nothing Universe." *Science News* 123, no. 7 (12 February 1983).

Thurston, William P., and Jeffrey R. Weeks. "Mathematics of Three-Dimensional Manifolds." *Scientific American* 251, no. 1 (July 1984).

Van Gogh, Vincent. *Van Gogh: A Self-Portrait, Letters Revealing His Life as a Painter, Selected by W. H. Auden.* Boston: Bulfinch Press, 1963.

Von Foerster, Heinz, and staff. *B. C. L. Reports,* Biological Computer Laboratory, Department of Electrical Engineering, University of Illinois, Urbana, nos. 712 and 722.

Welch, Stuart Cary. *A King's Book of Kings.* Boston: Bulfinch Press, 1972.

Zukav, Gary. *The Dancing Wu Li Masters: An Overview of the New Physics.* New York: William Morrow and Company, 1979.

Index

Page references in **bold** are to illustrations.

Credits

Unless otherwise noted in captions, artwork is by Tony Robbin. The author gratefully acknowledges the following persons and organizations for permission to reproduce illustrations: page 17: Philadelphia Museum of Art, Louise and Walter Arensberg Collection; pages 24 and 110: Thomas Banchoff and Associates at Brown University; pages 26 and 29: General Research Division, The New York Public Library/Astor, Lenox, and Tilden Foundations; page 43: Art & Architecture Collection, Miriam & Ira D. Wallach Division of Art, Prints and Photographs, The New York Public Library/Astor, Lenox, and Tilden Foundations; page 44 (top): Roman painting from Mythological Room, Villa of Agrippa (near Pompeii), The Metropolitan Museum of Art, New York, Rogers Fund purchase; page 44 (bottom): The Metropolitan Museum of Art, New York, Anonymous Gift, 1932; page 46: Roman painting, first century, from the Cubiculum, Villa of Agrippa (near Pompeii), The Metropolitan Museum of Art, New York, Rogers Fund purchase; page 47: The Metropolitan Museum of Art, New York, Rogers and Gwynne M. Andres Funds, 1935; page 48: Yale University Art Gallery, Bequest of Stephen Carlton Clark, B.A., 1903; page 59: Claude Monet, *Water Lilies*, c. 1920 (oil on canvas, left panel of triptych, 6'6" × 14'), Collection, The Museum of Modern Art, New York, Mrs. Simon Guggenheim Fund; pages 61, 64, and 69: originally published in *Leonardo*, vol. 23, no. 1 (1990), pp. 140–141, Copyright ISAST 1990; pages 84–85: Koji Miyazaki; page 86: Paul J. Steinhardt; page 88: Yasushi Kajikawa, Synergetics Institute of Japan; page 95: Haresh Lalvani, computer image by Neil Katz; page 111: Charlie Gunn, The Geometry Center, University of Minnesota; page 125: The Metropolitan Museum of Art, New York, Gift of Arthur A. Houghton, Jr., 1970.

Van Gogh letter on pages 179–180 from *The Complete Letters of Vincent Van Gogh*. Reprinted by permission of Little, Brown and Company in conjunction with the New York Graphic Society, and Thames and Hudson, Ltd. All rights reserved.